IMAGES
of America

MARBLEHEAD
VOLUME I

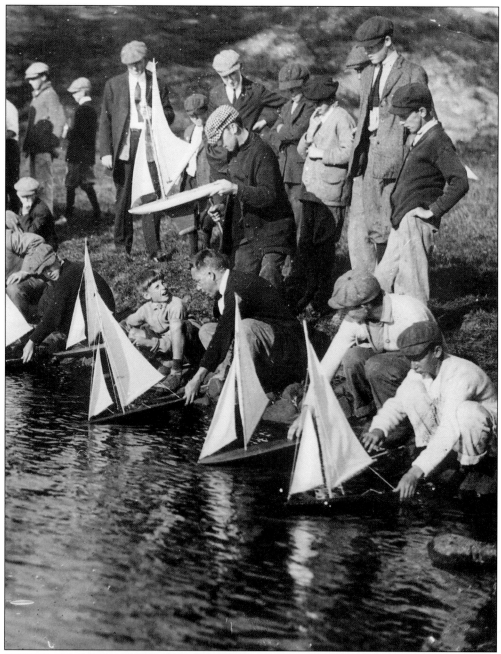

COVER ILLUSTRATION: The start of the race, Redd's Pond (photographed c. 1925).
Not a female is in sight as anxious fathers and sons, brothers and friends, check their handmade model yachts before the start of a Sunday-morning race on the picturesque pond adjacent to Marblehead's Old Burial Hill. The fraternal small-scale racing regattas were begun in 1894, and the earliest one-masted models were 24 inches long. (Courtesy Mr. and Mrs. Frederick William Edward Cuzner.)

IMAGES
of America

MARBLEHEAD
VOLUME I

John Hardy Wright

ARCADIA
PUBLISHING

Copyright © 1996 by John Hardy Wright
ISBN 978-0-7385-6446-3

Published by Arcadia Publishing
Charleston, South Carolina

Printed in the United States of America

Library of Congress Catalog Card Number: 2006927061

For all general information contact Arcadia Publishing at:
Telephone 843-853-2070
Fax 843-853-0044
E-mail sales@arcadiapublishing.com
For customer service and orders:
Toll-Free 1-888-313-2665

Visit us on the Internet at www.arcadiapublishing.com

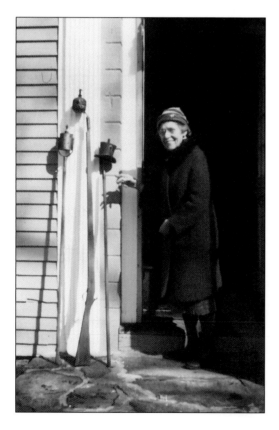

Helen Jaques at the front door of her home, the Philip Bessom House, 29 Beacon Street, with political campaign torchlights from her collection, c. 1974. This pictorial history of Marblehead is dedicated to the memory of Helen Woodbury Downing Jaques (1894–1976), who, when I knew her, was a lively little lady with a twinkle in her youthful eyes. Mrs. Jaques possessed a passion for the antiques she had inherited and collected, and for those she loaned for special exhibits at the former Essex Institute in neighboring Salem, when I was a much younger curator and historian at the museum. (Photograph by the author.)

Contents

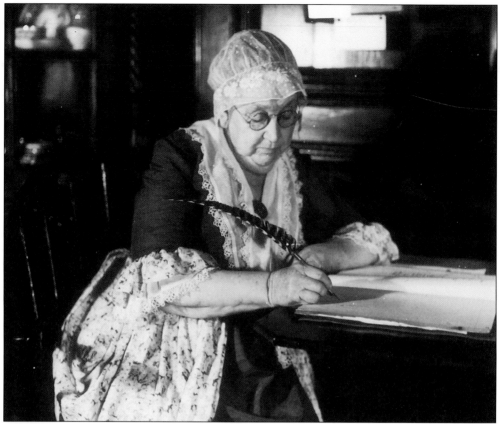

Miss Hannah Tutt pens a poem, c. 1929. Miss Hannah Tutt was a historian and author who on at least one occasion favored the acrostic poetic form. She wrote lovingly of her hometown in 1907, perhaps with the same quill pen she is using to sign a document as the first secretary and historian of the Marblehead Historical Society, founded in 1898. Miss Tutt is shown in a colonial costume, probably during the week-long tercentenary, held in 1929. (Courtesy Marblehead Historical Society, Marblehead, Massachusetts.)

Many a headland and rocky steep,
Affording rare views of old ocean deep,
Rough worn ways, leading up and down,
Bringing you into the queer old town,
Like a bit of the ancient days,
Escaped from the touch of more modern ways,
Houses quaint and old and brown,
Each with a history of its own,
And proud of its heroes, living and dead,
Did you not know—this is Marblehead.

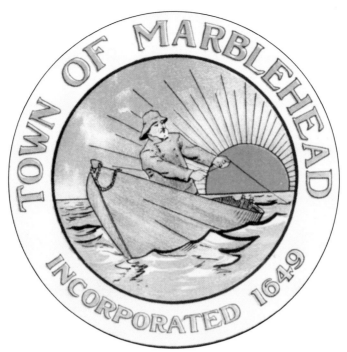

Town Seal, designed by Lynn, Massachusetts, artist William Johnson Bixbee (1850–1921), 1909. (Courtesy Marblehead Historical Society.)

Introduction

Long before he was honored as "The Father of His Country," George Washington made a side trip to Marblehead on October 29, 1789, while touring New England. The amiable general commented that the town, which even then consisted of aging wood-framed dwellings, had "the look of antiquity." In a letter to the citizens thanking them for their hospitality, Washington noted that their "attachment to the Constitution of the United States is worthy of men who fought and bled for freedom, and who know its value." Fervent patriotism and isolationism were characteristics retained by the townspeople up to the time the "strangers" arrived (around the mid- to late nineteenth century, when the Irish Catholics settled in Marblehead's Shipyard area at the town's southerly end).

The early English settlers of "Marble Harbor" (as it was known briefly in the early seventeenth century) were fishermen by heritage and by necessity, since the rocky terrain along the coast prevented them from engaging in much farming. Indeed, land purchase was nigh impossible for the scores of fishermen who chose to live there. At first, the rough and brusque fishermen hooked their valuable catch in coastal waters, later venturing to the Grand Banks off Newfoundland, whose fish-rich waters were seemingly inexhaustible. They sold the fish in Salem and Boston initially, but early in the 1700s merchants in Marblehead began shipping the lucrative cargo to distant Atlantic ports, bringing great profit to the town until the Revolution. The fish trade, with its odious drying of the "sacred cod" on fish flakes, or wooden stages, sustained the inhabitants until 1846, when a powerful September gale at the Grand Banks decimated the

fleet of fishing vessels and the breadwinners (and sons) of many families.

A long period of stagnation without employment prevented the remodeling of old dwellings and the construction of new buildings in the old part of town, thus saving, through benign neglect, most of the magnificent "old homes of the sea kings" and the vernacular abodes of their less-wealthy neighbors.

Around the turn of the twentieth century, trolleys brought tourists to Marblehead in search of seaside sun and homemade chowder (pronounced "chowdah") or a shore dinner offered at several restaurants and grills not far from scenic, historic Fort Sewall.

With its close proximity to Boston (the town is located 16 miles northeast of the capital city), Marblehead, which was settled in 1629 and incorporated as a town in 1649, is today a delight to many Americans who did not experience growing up in a small, somewhat secluded locale. And seeing *The Spirit of '76*, the majestic historical painting of the Revolutionary War period in Abbot Hall, makes visitors realize that they are in a special colonial town—one whose tenacious roots go back to the mother country of England, and one whose branches have sprouted native-born, fiercely independent individuals for more than three-and-a-half centuries.

Note: The images in each chapter are arranged in chronological order, with a few minor exceptions.

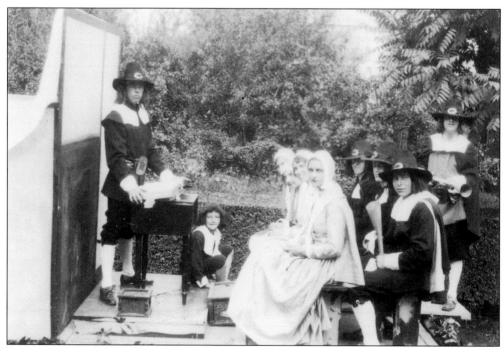

A tercentenary play (photographed 1929). These unidentified young people wore early-seventeenth-century-style costumes, and were loaned some antique accessories, for this out-of-doors play staged to celebrate the 300th anniversary of the founding of Marblehead. (Courtesy Marblehead Historical Society.)

One

The Colonial Period

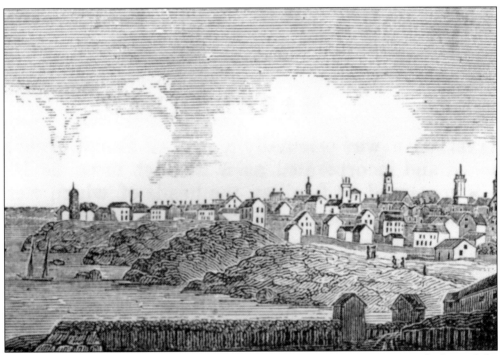

Northeastern view of Marblehead from Fort Sewall (wood engraving, 1839). One of the earliest representations of Marblehead and its "deep and excellent" harbor appears in John Warner Barber's *Historical Collections . . . of Every Town in Massachusetts.* In his five-page narrative on Marblehead, the artist-author mentions and depicts the five handsome churches then standing, shown with a few of the town's approximately 5,549 inhabitants walking along Front Street. Barber noted that, as seen from the pre-Revolutionary bulwark of Fort Sewall, the "village is quite novel in its appearance, being compact and very irregularly built, owing to the uneven and rocky surface of the ground. . . ." (Author's collection.)

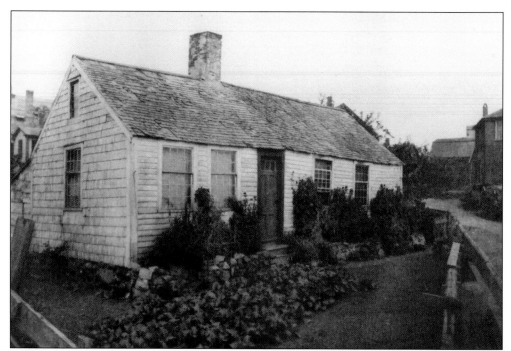

William S. Gardner House, 7 Gregory Street, built c. 1636 (photographed 1892). One of the most admired and photogenic dwellings in town is this unpretentious one-story clapboard and shingle-faced house overlooking the harbor. Tradition has it that John Peach used the structure as a fish house across the harbor on Marblehead Neck, and that it was later moved by oxcart to its present location. (Courtesy Mr. and Mrs. Alexander Parker.)

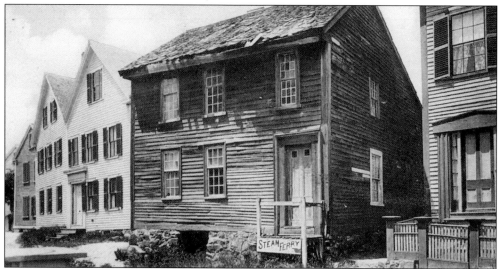

"Old Tucker House," formerly at 64 Front Street, built mid- to late seventeenth century (1905 postcard). An old stone foundation is as pronounced as the overall deteriorating condition of what many nineteenth-century local historians believed was one of Marblehead's earliest First Period dwellings. Built by John Codner in a field near Gregory Street and later moved to the site opposite Ferry Lane, the ramshackle house was photographed in raking sunshine several years before it was demolished. (Courtesy Mr. and Mrs. Robert Swift.)

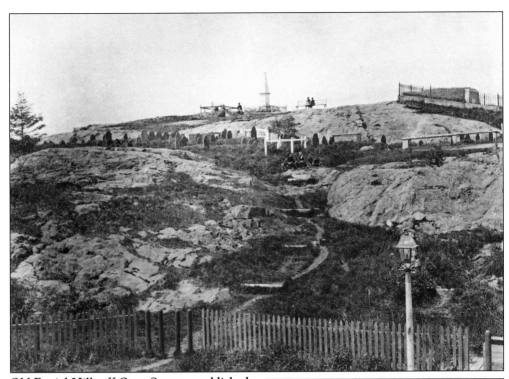

Old Burial Hill, off Orne Street, established in 1638 (photographed c. 1890).
Marblehead's first meetinghouse was built around 1638 on or near the top of this barren, rocky hill, and it was soon surrounded by the graves of the faithful, as was the custom in England. About six hundred casualties of the Revolutionary War are buried here, as well as several of the town's early ministers. The white marble obelisk was erected in 1848 by the Charitable Seamen's Society in memory of its deceased members on shore and at sea. (Courtesy Parker collection.)

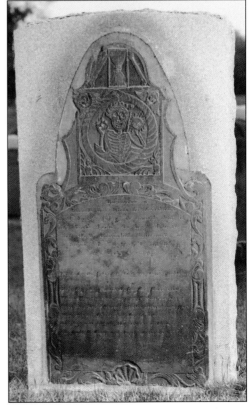

Susanna Jayne gravestone, Old Burial Hill, 1776 (photographed 1996). Late Puritan funeral iconography enlivens this tall slate gravestone (stabilized c. 1974) to record the life of one "who lived Beloved and Died Universally Lamented." Among the morbid motifs the unidentified stonecarver included was the upper torso of a skeleton holding a miniature version of the sun in one hand and perhaps the moon in the other, surrounded by a coiled snake biting the tip of its tail. (Photograph by Bill Lane.)

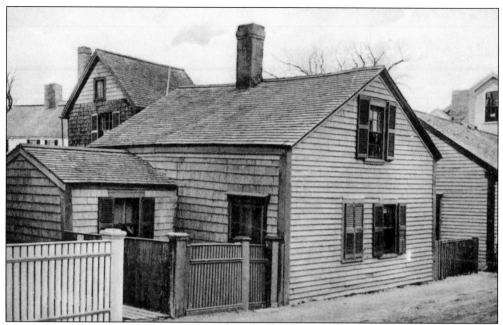

"The Old Pirate Cottage," formerly on Front Street near Fort Beach, built mid- to late seventeenth century (c. 1905 postcard). This simple one-and-a-half-story house that eventually served as a tearoom and gift shop owes its romantic name to the story of an early resident who left the cottage to join a band of pirates. All the structures on the same side of the street between Selman and Franklin Streets were razed or remodeled during the early twentieth century, when restaurants and gift shops began to appear in the area. (Courtesy Swift collection.)

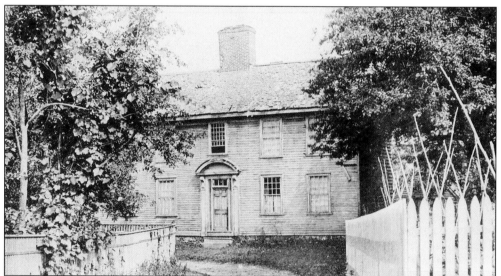

Doak House, Doak's Lane, built c. 1675 (photographed c. 1905). A center chimney, a symmetrically placed front entrance with an arched pediment supported by brackets, and twelve-over-twelve sliding sash windows gave a Georgian appearance to this "very ancient house . . . which unfortunately has disappeared [around 1908]." Doak's Lane is located off Orne Street before Gas House Lane. (Courtesy Benjamin R. Chadwick.)

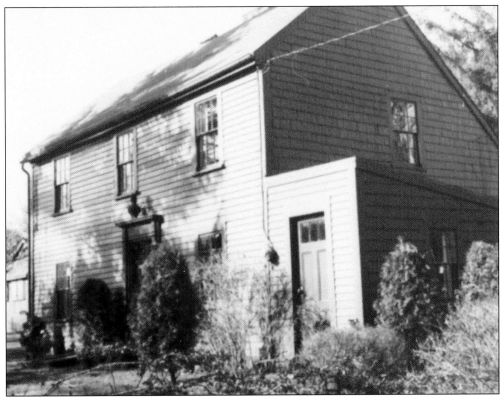

"Black Joe's" Tavern, 27 Gingerbread Hill, built c. 1690 (photographed 1958). This late-seventeenth-century lean-to (restored in 1956) is located on a meandering street at the summit of a hill with the fascinating name of Gingerbread. Joseph Brown, a freed black slave who had fought in the Revolutionary War, was the congenial tavern keeper and fiddler; his wife, known to all as "Aunt Crese," baked cakes and everyone's favorite—lily-pad-shaped molasses and ginger cookies called "Joe Froggers." (Courtesy Mr. and Mrs. David F. Barry.)

Captain William Dimond House, 42 Orne Street, built c. 1710 (c. 1905 postcard). Popularly known as "The Old Brig," this turn-of-the-century house, thought in the past to have been made from the timbers of a salvaged vessel, was later the residence of Edward Dimond, who was regarded by many as a wizard and a seer. Dimond's grandniece, Moll Pitcher, the fortune teller of Lynn, was born in this dwelling, which is situated near the base of Old Burial Hill. (Courtesy Swift collection.)

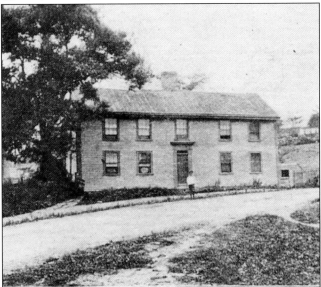

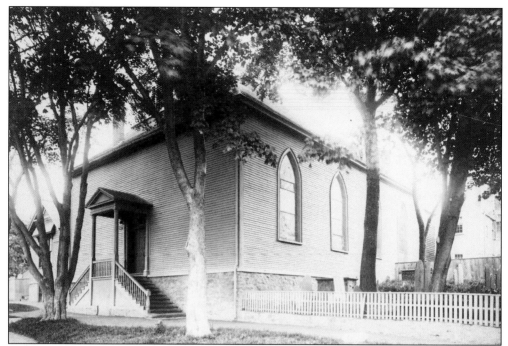

St. Michael's Episcopal Church, 26 Summer Street, built 1714 (photographed c. 1890). This is the oldest Anglican church in Massachusetts and the oldest in New England still on its original site. Following the reading of the Declaration of Independence in town, local patriots stormed into the closed church, ripped the royal coat of arms from its place of honor, and rang the bell until it cracked! (Courtesy Abbott Lowell Cummings.)

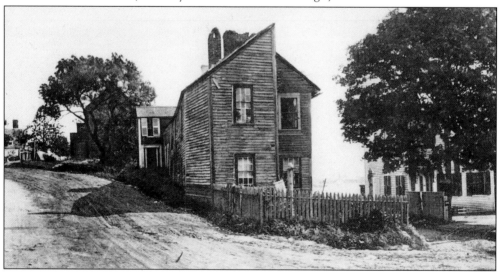

"Old Spite House," 39 Orne Street, built c. 1715 (c. 1905 postcard). Usually depicted in an unsightly condition, this interesting house built for Robert Wood at the intersection of Orne Street and Gas House Lane got its nickname through oral history: three fishermen brothers surnamed Graves supposedly did all they could to ignore and spite each other. The dirt road behind the house leads to the former Old Fountain Inn and Agnes Surriage's Well, and, to the left, to Old Burial Hill and Barnegat. (Courtesy Swift collection.)

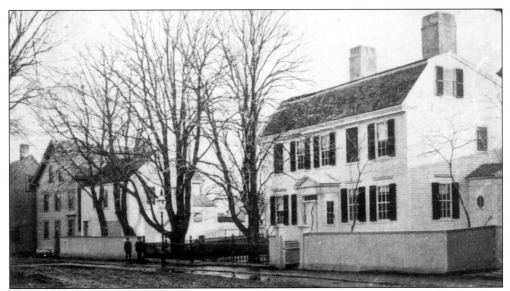

Parson Barnard House, 7 Franklin Street, built 1716 (photographed c. 1926). A smaller section of this early Georgian dwelling was home to the persuasive minister who encouraged local fishermen to sell their catch abroad instead of only in Salem and Boston; this proved to be a financial success and turned the tide for the fishermen and the town. When Barnard died at the age of eighty-nine, church members and townspeople knew they had lost a "burning and shining light for many years." (Courtesy Marblehead Historical Society.)

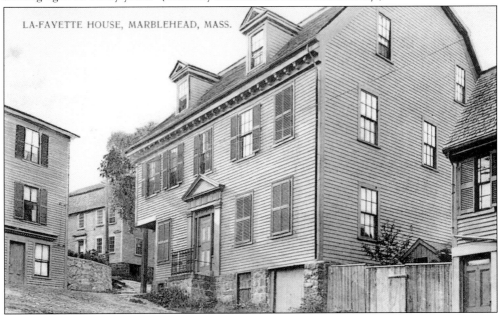

Minot-Palmer House, 2 Union Street, completed in 1731 (c. 1910 postcard). The unusual cutaway corner at the intersection of Lee and Hooper Streets led some nineteenth-century locals to nickname this dwelling "The Lafayette House" in reference to the inability of the French general's carriage to maneuver the corner. A logical explanation for the architectural amputation is the width of later timber and coal wagons that made their way into town from the wharves to the west of Bartoll's Head. (Courtesy Swift collection.)

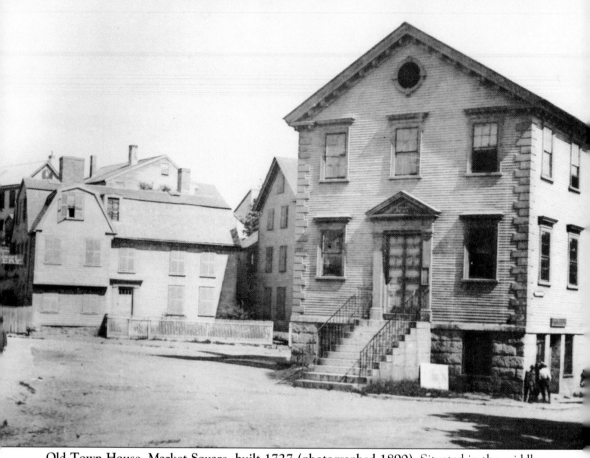

Old Town House, Market Square, built 1727 (photographed 1890). Situated in the middle of what became known as Market Square and constructed on the site of the "Old Gaol," this wood-framed public building is similar in style and function to Boston's larger brick Faneuil Hall. On either end of the building, the pediments on the two identical entry doors show the construction date of 1727. At the market first opened here in 1763, townspeople could buy produce every Tuesday and Thursday until 1 pm and until sunset on Saturday. Before the Revolutionary War speeches were delivered here by local firebrands such as Azor Orne, and the building was the rallying and departure point for troops involved in that war, the Civil War, the Spanish-American War, and World War I. The second floor of the Town House, formerly occupied by the John Goodwin, Jr. Post, Grand Army of the Republic was set up as a museum by the Marblehead Historical Society. Town offices were located here until Abbot Hall was built on Training Field Hill in 1877. The gambrel-roofed house with overhang in the background was built around 1695 for cordwainer William Waters, and was altered and enlarged in 1735 for scrivener Nathan Bowen. (Courtesy Parker collection.)

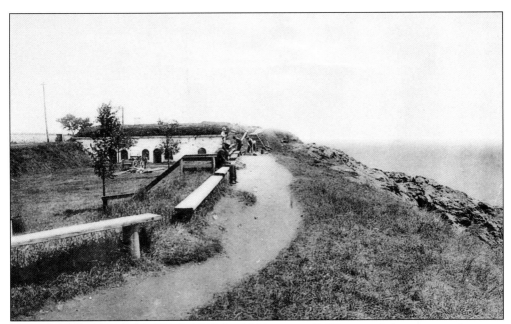

Fort Sewall, built at Gale's Head, 1742 (c. 1900 postcard). The rounded promontory between the larger and smaller harbors served as "a good and sufficient breastwork" until the end of the Spanish-American War in 1898. It was deeded in 1922 to the town by the federal government for use as a park in perpetuity. The fortification was named Fort Sewall in 1814 to honor local town official Samuel Sewall, who became the chief justice of Massachusetts. (Courtesy Swift collection.)

Agnes Surriage's Well, Fountain Inn Lane, off Orne Street (photographed c. 1895). In 1930 the Massachusetts Bay Colony Tercentenary Commission erected a free-standing marker to commemorate the story of a young local woman's rise from rags to riches. A poor fisherman's daughter, Agnes Surriage was noticed beside the well and befriended by Sir Harry Frankland, collector of the Port of Boston, when he was in charge of the construction of Fort Sewall in 1742. Much later she became Lady Frankland, owing perhaps to her having saved Sir Harry's life after an earthquake in Lisbon, Portugal. (Courtesy Vincent F. McGrath.)

17

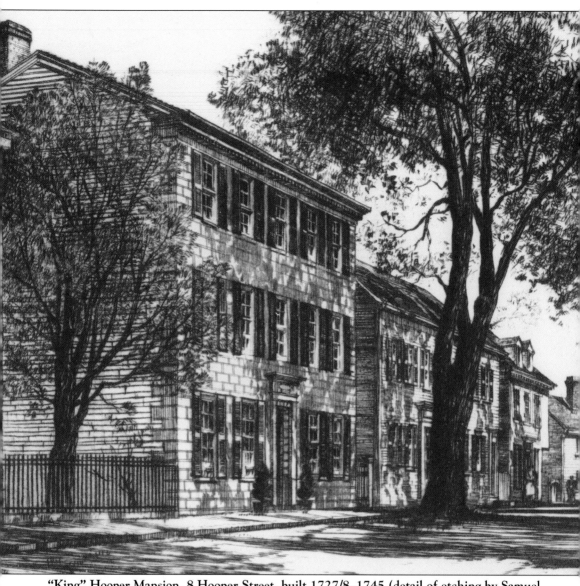

"King" Hooper Mansion, 8 Hooper Street, built 1727/8–1745 (detail of etching by Samuel Chamberlain, 1940). Two houses away from the Minot-Palmer House is the grand mid-eighteenth-century home of the prosperous merchant Robert "King" Hooper (1709–1790). It boasts a rusticated and quoined facade as does his other house (later the home of William Raymond Lee) on upper Washington Street opposite Abbot Hall, and the fully rusticated Jeremiah Lee Mansion, both built in 1768. Jason Chamberlain acquired the Hooper Mansion in 1819, and his heirs later used the first floor rooms as a dry goods store until 1888, when the Young Men's Christian Association purchased the property. Israel Sack, before becoming a prominent antiques dealer in New York City, had his main showroom in the third floor ballroom (where the YMCA had had its gymnasium) between 1923 and 1932. In 1938 the former mansion was saved from conversion or possible demolition by fellow artists Samuel Chamberlain and Arthur W. Heintzelman, together with their wives and Elisabeth Brackett Alsberg, who raised enough seed money ($250) during the Depression years to make it the new home of the Marblehead Arts Association. (Courtesy Christine Vining Antiques.)

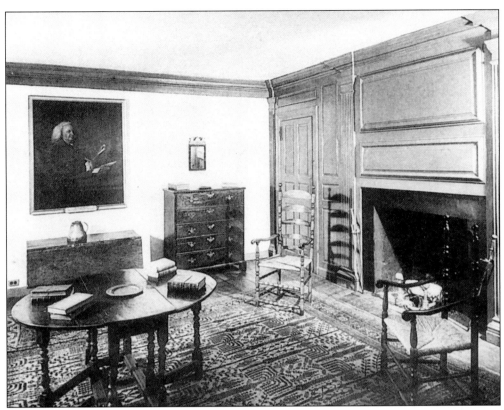

Bedchamber in Hooper Mansion, 8 Hooper Street, c. 1745 (c. 1940 postcard). A reproduction of the original 1767 oil portrait by John Singleton Copley of Robert "King" Hooper (The Pennsylvania Academy of the Fine Arts, Philadelphia) dominates the second-floor room of his former home, which also contains examples of locally owned furniture and decorative arts. The philanthropic merchant dominated the Marblehead fish trade in foreign ports, but as a loyalist he forfeited his estate and holdings when he sequestered himself at his country home in Danvers during the Revolutionary War. (Courtesy Swift collection.)

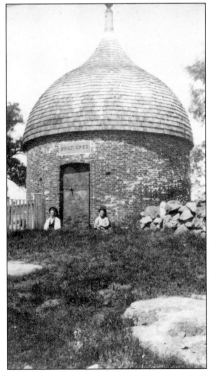

Powder House, 35 Green Street, built 1755 (photographed c. 1885). This small, circular building constructed of coarse brick was initially used as a storage facility for ammunition and arms during the French and Indian War (1754–1763). One of only three pre-Revolutionary buildings of its type in existence in America, it has a domed roof said to have been designed in anticipation of a possible explosion which would send it flying without—hopefully—harming the curved, double-thick walls. (Courtesy McGrath collection.)

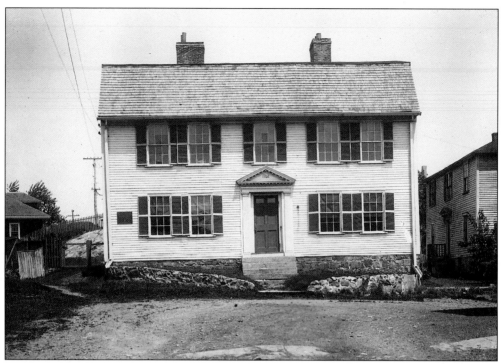

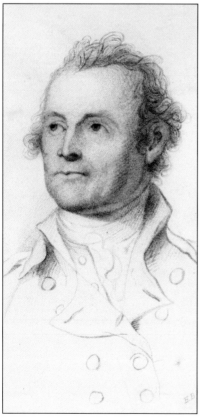

Brigadier General John Glover House, 11 Glover Square, built 1762 (photographed c. 1925). This colonial dwelling is nestled on elevated land on an L-shaped street near the harbor. A bronze tablet placed to the left in 1923 by the local chapter of the Daughters of the American Revolution reads: "IN THIS HOUSE LIVED JOHN GLOVER BRIG. GEN. IN THE CONTINENTAL ARMY LEADER OF THE CELEBRATED 'AMPHIBIOUS REGIMENT' OF MARBLEHEAD, WHO ROWED WASHINGTON AND HIS ARMY SAFELY ACROSS THE DELAWARE AT TRENTON, DEC. 25, 1776 AND SERVED WITH DISTINCTION AT LONG ISLAND AND VALLEY FORGE." (Courtesy Chadwick collection.)

Brigadier General John Glover, engraved by W. Pate after the pencil drawing by John Trumbull (mid-nineteenth century). Feistiness was not an endearing quality of the determined red-haired naval hero (1732–1797). Sadly, he outlived his second wife and most of his children, and spent his last years as a cordwainer to support himself. A bronze statue of General Glover by the Irish-born sculptor Martin Milmore (1844–1883) has adorned the Commonwealth Avenue Mall (between Berkeley and Clarendon Streets) in Boston since 1875. (Courtesy Russell W. Knight collection.)

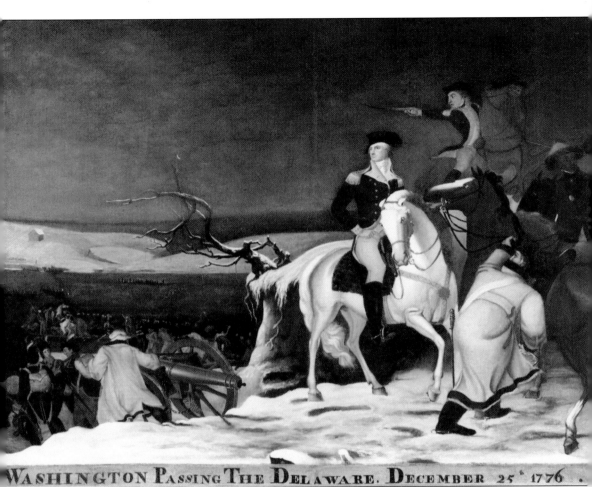

WASHINGTON PASSING THE DELAWARE. DECEMBER 25ᵗ 1776 .

Washington Passing the Delaware, December 25th 1776, oil on canvas by William T. Bartoll (1812–1859), c. 1850. The local folk artist's largest non-portrait painting has a historic connection with his birthplace. Sometime after 1841, while at the Boston Museum and Gallery of Fine Arts (as the Museum of Fine Arts was called), Bartoll saw the immense 1819 history painting that Thomas Sully (1783–1872) was commissioned to complete for the capitol of the state of North Carolina. Impressed with the size and subject matter of Sully's painting of General George Washington's famous nocturnal crossing of the Delaware River, Bartoll made this scaled-down version (approximately 54-by-82 inches) in his own painterly style and included the title for all to see. (Property Town of Marblehead; on view at Abbot Hall; photograph by Bill Lane.)

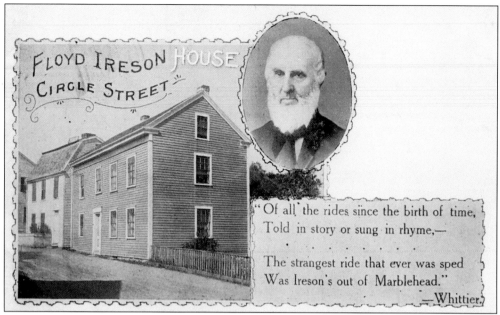

"Of all the rides since the birth of time,
Told in story or sung in rhyme,—

.

The strangest ride that ever was sped
Was Ireson's out of Marblehead."
—Whittier.

Floyd Ireson House, 19 Circle Street, built before 1808 (c. 1910 postcard). Skipper "Flud" Ireson, the captain of the fishing vessel *Betty*, supposedly declined to assist another vessel in trouble during a gale in 1808; in retribution for this, he was tarred and feathered by the townspeople. Amesbury, Massachusetts, poet John Greenleaf Whittier (1807–1892), shown as an elderly man in the oval insert, had his poem "Skipper Ireson's Ride" published in the *Atlantic Monthly* in 1857. (Courtesy Swift collection.)

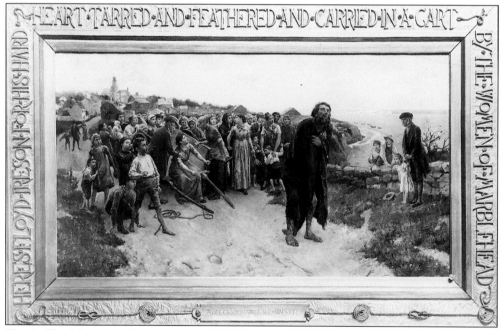

Here's Floyd Ireson, oil on canvas by Will H. Low (1853–1932), 1881. The hand-carved frame on this history painting incorporates the opening lines of Whittier's poem in relief on three sides, along with coiled and knotted rope decoration. (Courtesy Knight collection.)

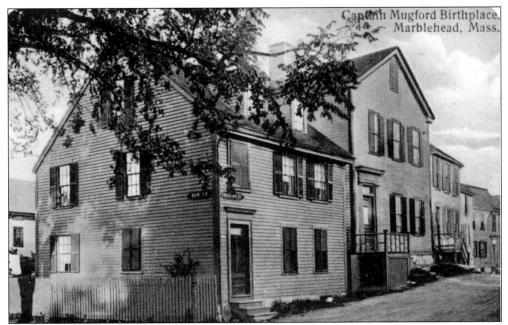

Not the Captain Mugford birthplace, 39 Mugford Street, built c. 1758 (c. 1913 postcard). Located on what was formerly New Meeting House Lane at the corner of Elm Street, this house is not where James Mugford Jr. was born (as noted on the postcard), but where he and his bride lived briefly when first married. (Courtesy Swift collection.)

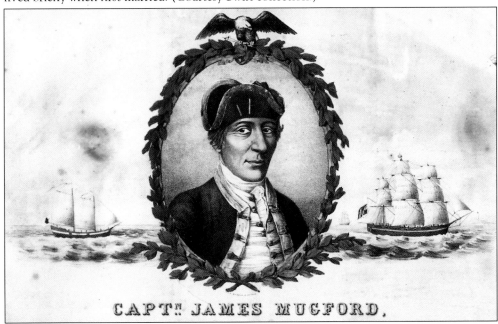

Capt. James Mugford of the Schr. Franklin Continental Cruiser 1776 (1854 lithograph by L.H. Bradford & Co., Boston). Valiant Captain Mugford died on May 19, 1776, during a naval engagement in Boston Harbor. The seizure of the armament and tools on the British "Powder Ship" was "One of the most valuable prizes during the Revolution . . . this and similar events produced the general voice 'We will be free.'" (Courtesy Chadwick collection.)

Marblehead Academy, 44 Pleasant Street, built 1789 (photographed c. 1870). The first school in Marblehead was located in teacher Edward Humphrey's house in 1675, and then only intermittently. Incorporated in 1792, the Marblehead Academy was located in a wood-framed Neoclassical building with grades one through three held in rooms on the first floor. The academy building was razed in 1879, and a new brick school was built on the site. (Courtesy McGrath collection.)

Marchant School, High Street, built 1800 (c. 1905 postcard). A promissory note left by Captain John Marchant of Marblehead, who died at sea near Batavia, prompted the construction of two identical one-room schoolhouses in town. Located on Idler's Hill just above "The Old Alley Steps" connecting High Street to Washington Street, this building usually appears in derelict condition on postcards. In 1837 the first high school in town was established in the Masonic Lodge building. (Courtesy Charles F. Maurais.)

Two

Jeremiah Lee's Magnificent Mansion

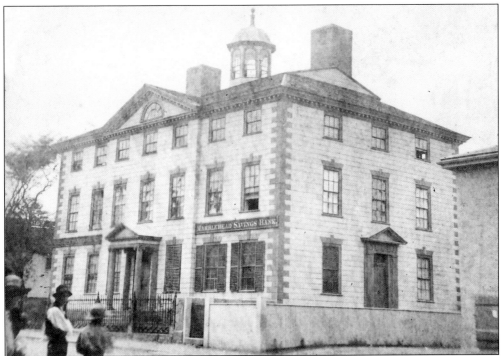

Jeremiah Lee Mansion, 161 Washington Street, built 1768 (photographed 1890). Long regarded as one of about eight great Georgian-style houses in America, the Lee Mansion is now, and was during its time, the most imposing dwelling built in New England before the Revolution. The Lees' magnificent new home was modeled after the grand Palladian-style country houses of the English elite, the design apparently derived from an illustration in Robert Morris's architectural pattern book, *Select Architecture*, first published in 1755. The octagonal domed cupola with its arched windows must have served as the ideal spot for the merchant Lee, or members of his family, to watch for incoming vessels. In 1804 the Marblehead Bank purchased the building and owned it for almost a full century. On July 4, 1909, the Marblehead Historical Society acquired the property for its headquarters. (Courtesy McGrath collection.)

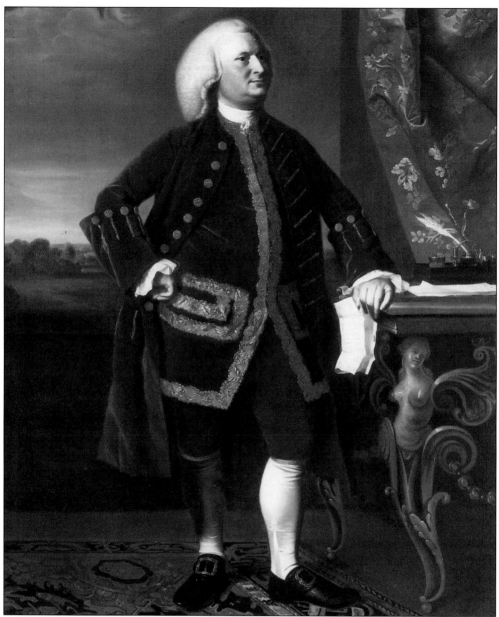

Jeremiah Lee (1721–1775), oil on canvas by John Singleton Copley (1738–1815), 1769.
This life-size portrait of the first owner of the mansion that bears his name was painted by the most famous artist in Colonial America. Like other prominent individuals seeking to represent their high social station, Lee is shown in fashionable attire—a powdered wig and resplendent silk and velvet apparel. However, the furniture depicted was never in his Marblehead home. Lee's grand surroundings were English features Copley used to give his affluent clients a more aristocratic presence. Even though his material interests were associated with the mother country, Lee was a staunch patriot, serving as a colonel in the local regiment and a member of important provincial political committees. Lee contracted a fatal fever while evading British troops in a field near Lexington on April 19, 1775. (Courtesy Wadsworth Athenaeum, Hartford; the Ella Gallup Sumner and Mary Catlin Sumner Collection Fund.)

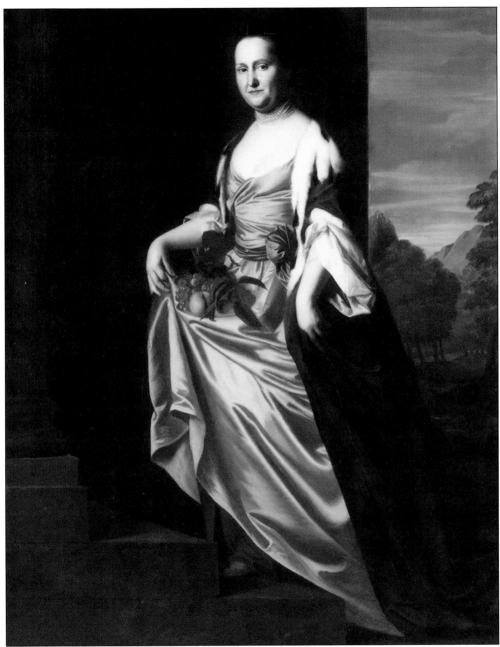

Mrs. Jeremiah Lee (1726–1791), oil on canvas by John Singleton Copley (1738–1815), 1769. In the companion portrait, Martha Swett Lee, the daughter of a prominent Marblehead family, is shown in a luxurious, loose-fitting silk caftan with an ermine-trimmed cloak as she graciously ascends stairs in an aristocratic country estate that was not her home. Sometime after the death of her husband, Mrs. Lee and her younger children moved to Newbury, in northern Essex County, where her married daughters and grandchildren lived. A pair of late-nineteenth-century reproduction oil portraits of the Lees grace the stair landing of the mansion precisely where the original paintings are believed to have been displayed. (Courtesy Wadsworth Athenaeum, Hartford; the Ella Gallup Sumner and Mary Catlin Sumner Collection Fund.)

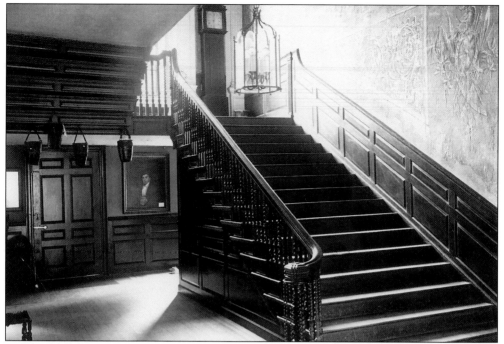

Entrance hall (photographed c. 1930). Visitors to this National Registered Historic Landmark (1963) are overwhelmed by the generous proportions of the passage or central entrance hall and the grand staircase, nearly 8 feet wide. In the spirit of the Colonial Revival, a tall-case clock has a position of honor on the stair landing, and hand-painted leather fire buckets hang in a nostalgic manner. Visitors to the mansion included George Washington, James Monroe, Andrew Jackson, and the Marquis de Lafayette. (Courtesy Marblehead Historical Society.)

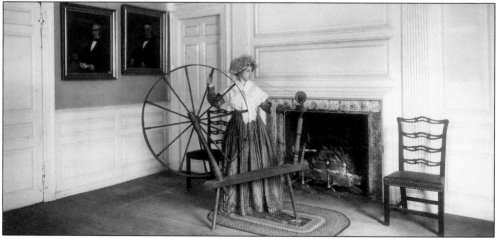

Parlor (photographed 1914). The small parlor opposite the formal parlor is now filled with more period furniture and decorative accessories than are shown in this photograph. The portraits on the wall are of Captain Jonathan Thompson (left) and Captain Richard Girdler, both attributed to William T. Bartoll. Bewigged Margaret Day is standing on a hooked and braided rug while spinning on a nineteenth-century great wheel—another turn-of-the-century activity affected for the sake of the photographer which would never actually have taken place in a household of this caliber. (Courtesy Marblehead Historical Society.)

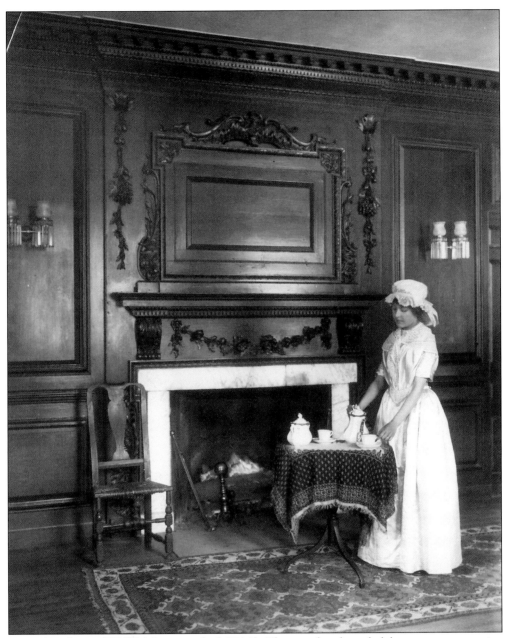

Formal parlor or "Hall" (photographed 1914). The grand scale and elaborate rococo carving in this room are unusual, but then Jeremiah Lee was an unusual merchant. The high-style carved rococo chimney breast was copied from a design in Abraham Swan's *British Architect*, published in 1745. Skilled colonial craftsmen, many of whom trained in England before emigrating to America, built and carved the mansion's paneling, moldings, and decorative embellishments, which include pierced and ruffled reverse C-scrolls, pendant fruit and flowers, and architectonic motifs. In 1851, while the mansion was owned by the Marblehead Bank, William T. Bartoll was hired to paint over the original yellow-painted woodwork in faux oak. The Colonial Revival vignette, photographed by Mary Harrod Northend (1850–1926) of Salem, shows Louise Shaw Curtis pouring tea. (Courtesy Marblehead Historical Society.)

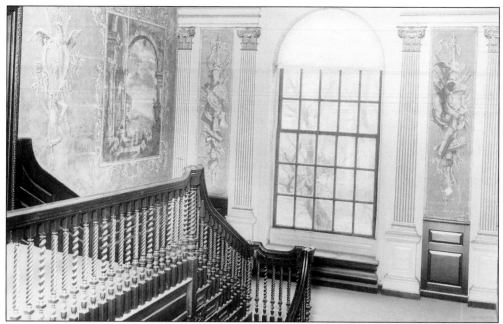

Stair landing (photographed c. 1930). The scenic English wallpaper panels hand-painted *en grisaille* (in shades of gray) have been on the walls in this area and in the two front bedchambers since they were installed in 1768. The three-story mansion measures about 10,000 square feet, and the sixteen rooms of various dimensions contain twelve working fireplaces and eleven closets. There is a full attic and a large cellar of brick and granite. (Courtesy Marblehead Historical Society.)

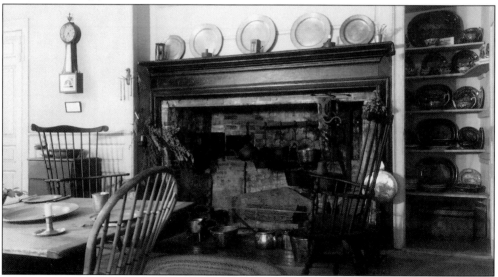

Kitchen (photographed c. 1930). When this photograph was taken by Samuel Chamberlain, the kitchen's marbleized mantelpiece was decorated with nineteenth-century metalware, including pewter plates and some simple lighting devices. The adjacent closet was used for the storage and display of blue-and-white transfer-printed utilitarian ceramic wares. Cast-iron and hammered copper and brass cooking utensils filled the hearth, and an imported clock jack for rotating the spit can be seen at the right. (Courtesy Marblehead Historical Society.)

Three

The Nineteenth
Century

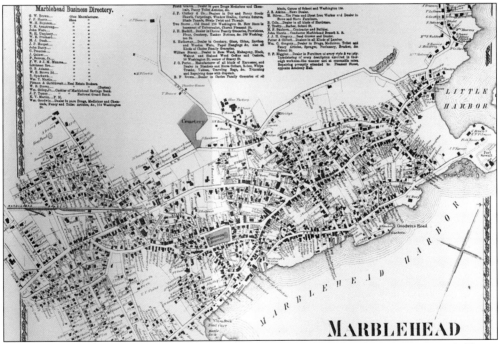

Map of Marblehead with business directory legend, Essex County Directory, 1872. Forty-three businesses paid to be listed in the legend of this late-nineteenth-century map. In 1882, eighty-three boot- and shoe-related businesses were included in another published directory of the town. Around the mid-eighteenth century when Marblehead was a flourishing fishing port, it had one of the largest populations in the Colonies. Inhabitants numbered 4,386 in 1776. By 1850 when the shoe industry was becoming established, 6,167 people resided in the town. The 1900 directory included 7,582 residents, during the post-shoe manufacturing period and the beginning of tourist-related businesses. Streets were first specifically identified in 1762 (many with names associated with England); in 1824 the names of the principal streets were changed by vote of the town. Marblehead was first surveyed in 1889, the year after the second great fire. (Courtesy Mrs. James Gosling Jr.)

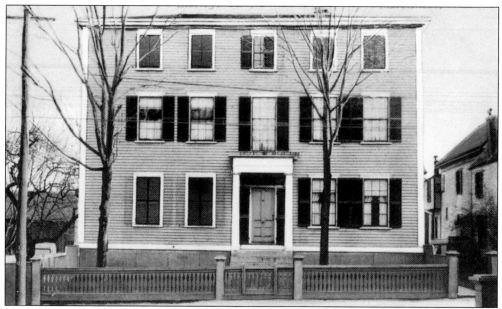

Elbridge Gerry House, 44 Washington Street, built c. 1805 (c. 1920 postcard). This straightforward two-and-one-half-story Federal house is situated diagonally across the street from the Old North Congregational Church. Elbridge Gerry was the most famous resident of the dwelling. Captain William Blackler, navigator of the boat that transported General George Washington across the Delaware River, was a later owner of the property. (Courtesy Maurais collection.)

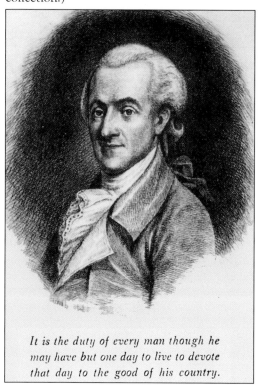

It is the duty of every man though he may have but one day to live to devote that day to the good of his country.

Elbridge Gerry (1744–1814), late-nineteenth-century engraving. The accompanying quotation appears on Elbridge Gerry's gravestone in Congressional Cemetery, Washington, D.C. A patrician patriot, Gerry was the town's representative to the first Continental Congress, a signer of the Declaration of Independence, and a governor of Massachusetts. The elegant and eloquent Elbridge Gerry died in office while vice president under James Madison. (Courtesy Knight collection.)

"Gerrymander," (1812 political cartoon). During his second term as governor of Massachusetts, Elbridge Gerry gave silent approval to a redistricting bill that changed the political shape of Essex County. In the form of a salamander, but called a "Gerrymander," this cartoon in *The Salem Gazette* shows the redistricting which benefited Gerry's fellow anti-federalists. Much to Gerry's regret, this derisive term was bandied about, and it is still used today to describe the division of a territorial unit to give one political party an electoral advantage. (Courtesy Swift collection.)

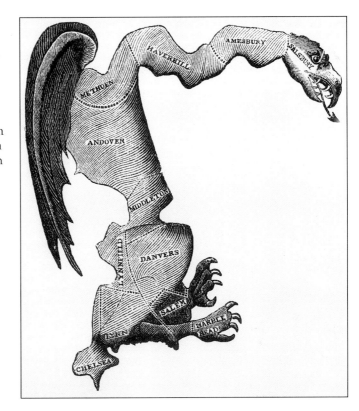

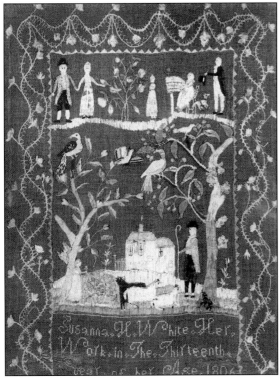

Sampler, silk on woven linen and wool, made by Susanna H. White, 1806. Thirteen-year-old Susanna Haskell White (1794–1819), the daughter of John and Ruth Haskell White, included childhood genre motifs and a shepherd with his flock in her "floating landscape" embroidered work. Noted sampler collector and author Betty Ring has written that "the incomparable samplers of Marblehead have no foreign counterpart and represent American girlhood embroidery at its best." (Courtesy Skinner, Inc.; present location unknown.)

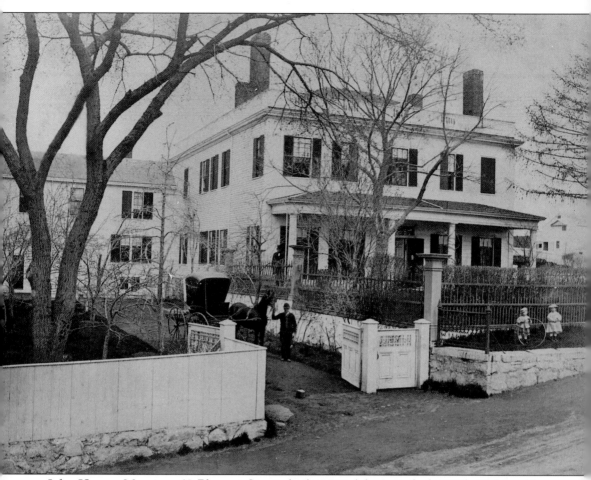

John Hooper Mansion, 69 Pleasant Street, built 1832 (photographed 1865). Fashionable Greek Revival houses, almost always painted white, began to dot the American landscape in the 1830s. This fine balustraded example, with a columned front porch, had fireplaces in each room, a carriage house, and two types of wooden fences. John Hooper, grandson of General John Glover, built the house in the latest style for his bride, Lydia Blackler. Hooper started his career at sea, as did so many young Marblehead men, and in time became a prominent banker and one of the wealthiest men in town. Henry Pitman, owner of the property when this early photograph was taken, is standing on the porch wearing a stovepipe hat. A servant holds the one-horse shay ready while two nicely dressed children play with a hoop on the raised terraced area. Miss Elizabeth Hall, another owner of the property, had heavy equipment installed in several rooms as part of a toy factory. In 1932 Dr. Nathaniel Mason acquired the neglected mansion and began the restoration continued so meticulously by the present owner, Dorothy Fogg Miles, and her late husband. (Courtesy Harriett Pitman Bull and Dorothy Fogg Miles.)

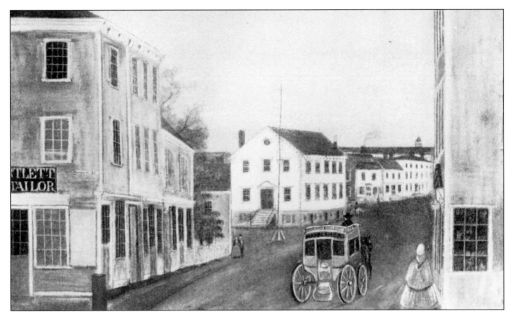

View of Washington Street with the Old Town House (mid-nineteenth century drawing).
An unidentified local artist drew this picture of the downtown area, showing a coach opposite
the Federal-period Hinkley Building on the corner of Pleasant Street. A tailor named Bartlett
was one of the merchants in the three-story building at the time. An interesting feature is the
tall flagpole in Market Square in front of the Town House. (Courtesy Marblehead Historical
Society.)

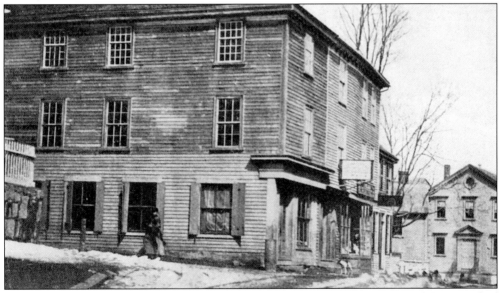

**Hinkley Building, corner of Washington and Pleasant Streets, built c. 1800 (photographed
before 1871).** A comparison of this image with the previous drawing reveals architectural
changes in the old structure but not in the Town House, which looked the same until it was
raised on a high granite foundation in 1832. The Hinkley Building was razed to widen the
street, and the George W. Grader Building was constructed on the site in 1885; later the area
became known as Cook's Corner. (Courtesy Swift collection.)

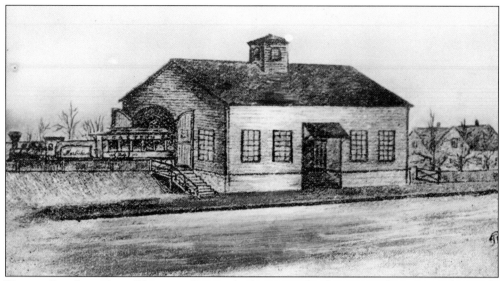

First railroad station, Pleasant Street, built 1839 (mid-nineteenth-century drawing). Stagecoaches provided commercial transportation twice daily between Marblehead and Salem prior to December 1839, when the Eastern Railroad inaugurated rail service on that branch. The first of four railroad stations on the site was a small, wood-framed structure with its main entrance directly on the street. (Courtesy Chadwick collection.)

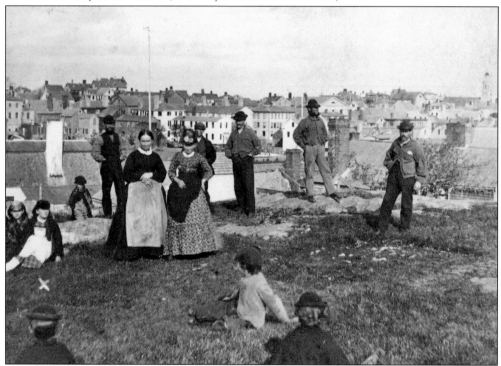

Bartoll's Head, later known as Crocker Park (photographed c. 1865). Near the end of the Civil War, a group of assorted townspeople gathered together for this informal stereopticon view. The men standing to the right at the top of the rocky hill flank a house under construction. (Courtesy McGrath collection.)

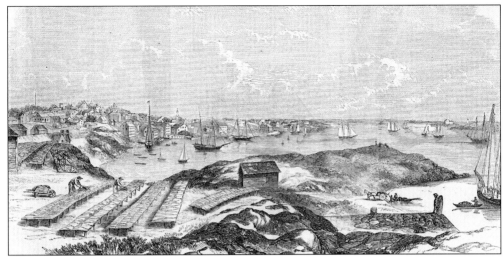

View of the Town of Marblehead, Massachusetts, wood engraving in *Gleason's Pictorial Drawing-Room Companion,* **1854.** The drying of the "sacred" cod and other edible fish could be seen and smelled on many rocky hills along the shore. Numerous wooden frames, or "flakes," supported the fish, which were dried and cured in the air and sun. This sweeping mid-nineteenth-century view of the town from Skinner's Head, with the Great Neck at the right, shows fishermen at work with a wheelbarrow and a fishing shanty nearby. (Courtesy Stanley S. Sacks Antiques.)

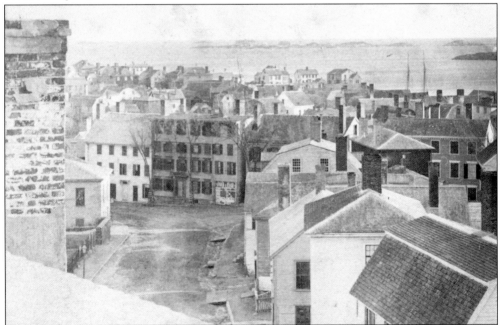

View of Washington Street toward Bank Square (photographed c. 1875). This bird's-eye view from a rooftop near Training Field Hill shows the area where four banks were once located on Hooper Street and the lower end of Washington Street. The unique 1831 Grand Bank, with its granite facade, was named for the fishing territory off Newfoundland where so many fishermen caught their living. A two-masted vessel is docked in the inner harbor, and Cat Island is visible in the distance. (Courtesy McGrath collection.)

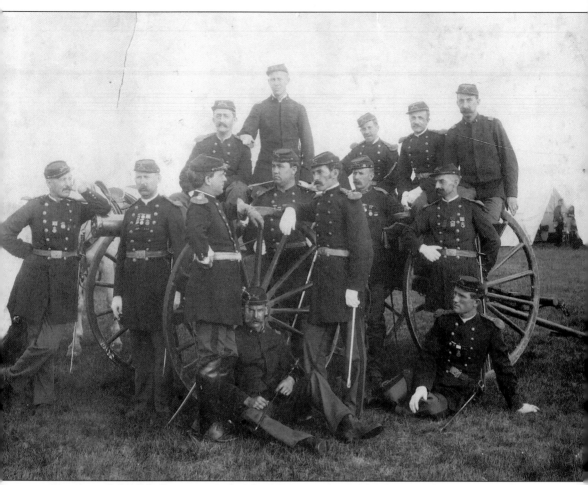

Company C Eighth Regiment Infantry, USV, in the field (photographed after 1865). In this post-Civil War photograph, Marblehead soldiers are shown at an unidentified campsite around a Gatling rapid-fire machine gun in dress uniform, several with swords at their sides. An outgrowth of the Marblehead Light Infantry, which was organized in 1809, Company C had the distinction of being one of the first companies from the state to respond to President Abraham Lincoln's call to protect the Union. Under the command of Captain Knott V. Martin, it assembled at Faneuil Hall in Boston amid sleet and snow on the morning of April 16, 1861. Before completing its first tour of duty and returning triumphantly to Marblehead on August 1, Company C helped rescue the frigate *Constitution* from secessionists; it also opened railroad communications for troops between Annapolis and Washington, D.C., and guarded the nation's capital. On November 25, Captain Samuel C. Graves led Company C on its second tour, which lasted nine months. With volunteers from Baltimore, Maryland, the company pursued General Robert E. Lee's retreating army. At this time Colonel Benjamin F. Peach Jr. commanded the Eighth Regiment. Of the 1,048 men from the town who saw service during the Civil War, 827 were in the army and 221 in the navy; 110 died; 87 were seriously wounded; and other brave men were taken prisoners or remained missing. (Courtesy Marblehead Historical Society.)

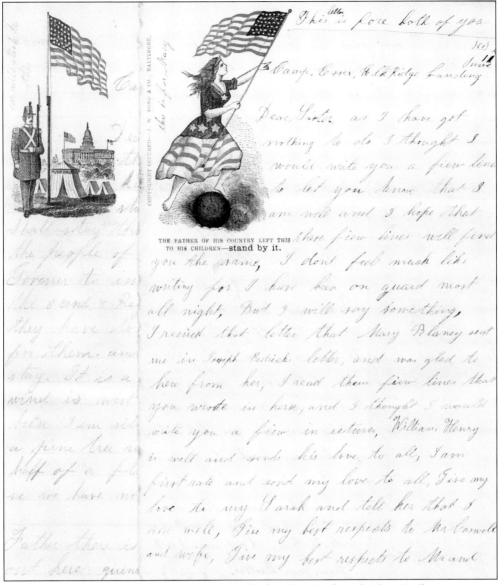

Two pictorial Civil War letters, 1861. Charles E. Winslow (1839–1916) wrote many delightfully misspelled letters to his loving family in Marblehead during three months of active duty, and these, on government-issue printed stationery with a patriotic and a military camp scene near the United States capital, are the most interesting graphically. Winslow was twenty-one when he enlisted on April 15, 1861; he was mustered into the Eighth Regiment of the Massachusetts Volunteer Militia on April 30 of that year, and mustered out three months later, on August 1. (Author's collection.)

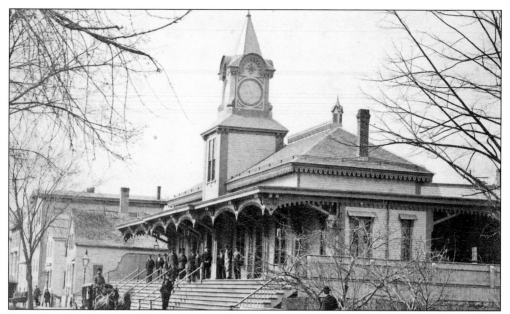

Second railroad station, Pleasant Street, built c. 1873 (photographed c. 1875). Gingerbread decoration enhanced the overhanging roof of the elevated wood-framed depot, with its fancy Victorian clock tower. Less than five years after it was opened for business, the building and other wooden structures were destroyed by the first great fire (1877) in the predominantly shoe-manufacturing center of town. (Courtesy Harry Wilkinson.)

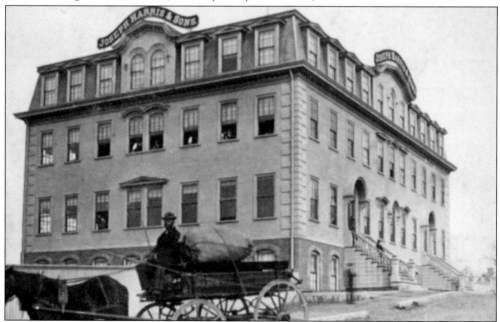

Joseph Harris & Sons shoe factory, Elm Street, built 1867 (photographed c. 1870s). Joseph Harris' Second Empire-style shoe factory was one of the largest businesses of its type in town. The wealthy entrepreneur employed hundreds of "Headers" at various tasks in the manufacture of shoes. The man driving the delivery wagon may be "H. Davis," as painted on the side of the vehicle. Fire destroyed the vacant building on July 17, 1894. (Courtesy McGrath collection.)

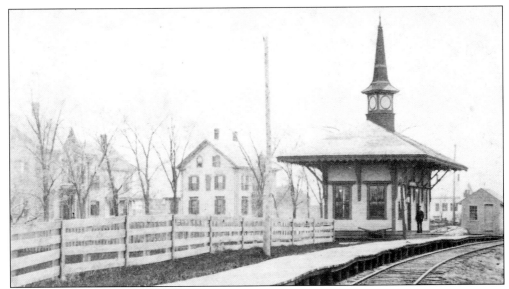

Devereux Train Station, built 1874 (photographed *c.* 1880). Similar small train stations, most likely designed by the same architect(s) and built at the same time, dotted the landscape in Marblehead. Passengers on the 17-mile ride to Boston's North Station left the Pleasant Street Station and were at the Devereux Station in two minutes. The angled clock in the depot's steeple kept commuters informed of the time for eighty-five years, until the structure was razed. (Courtesy Wilkinson collection.)

First Baptist Church and the Odd Fellows' Hall building, Pleasant Street (photographed *c.* 1875). The Rock Meeting House on Watson Street was the first Baptist house of worship in town, and the present church (built in 1868) is the second on the site at 17 Pleasant Street. The Odd Fellows' Hall building, next door at 11 Pleasant Street, was constructed in 1869 for Atlantic Lodge, No. 55. A sign for the town's first post office is visible at the left corner of the building, and the Western Union telegraph office was also located on the first floor. (Courtesy Wilkinson collection.)

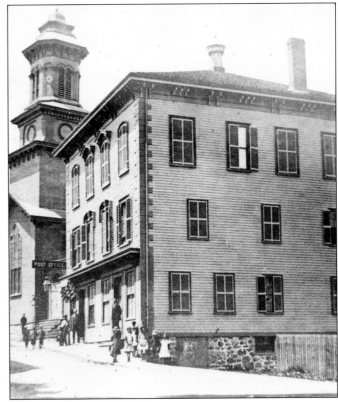

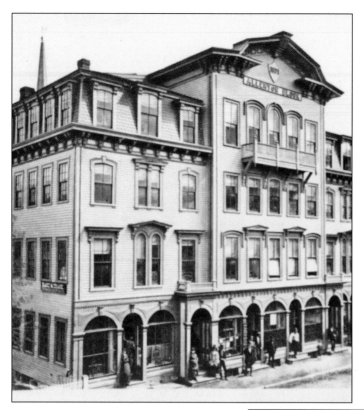

Allerton Block, Pleasant Street, built 1871 (photographed c. 1875). The name of this imposing building and its construction date appear under the shaped pediment of the projecting pavilion. With its symmetrical facade, the Allerton Block used space to its full potential, with many dormers placed in the Second Empire mansard roof. M.J. Doak & Company and Hart & Trask, mercantile job printers, were two of the businesses which occupied the building when all was lost in 1877 during the first great fire in Marblehead. (Courtesy McGrath collection.)

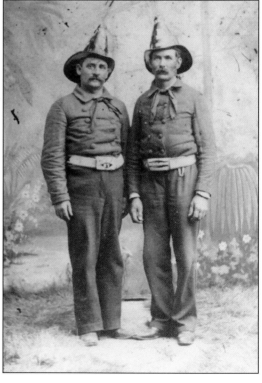

Firemen friends (photographed c. 1875). William Hammond (left) and Thomas Rhoades wear their heavy wool uniforms, leather helmets, and belts for this studio photograph while standing on a grass-like mat in front of an incongruous tropical painted backdrop. They were members of M.A. Pickett No. 1, the fire company on Franklin Street which was formed in May 1866. (Courtesy Thomas H. Rhoades Jr.)

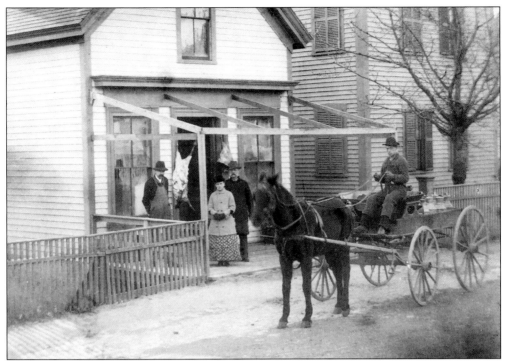

Ernest Allen's meat market, Bowden Street (photographed c. 1875). Recently butchered meat flanks the doorway of Allen's store, which probably had a summer awning attached to the wooden framework sometime after J.W. Perkins took this photograph. A young man identified as "Shackley" reins in his horse-drawn wagon filled with milk cans on the dirt road between Sewall and Bessom Streets. (Courtesy Marblehead Historical Society.)

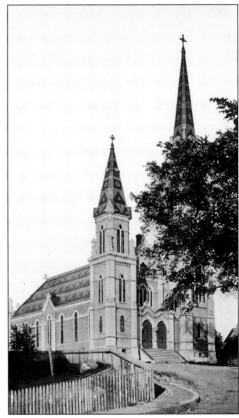

Our Lady, Star of the Sea Parish, Prospect Hill, enlarged and remodeled 1875 (c. 1915 postcard). Looking more like a late-nineteenth-century European cathedral, this Gothic Revival structure, with patterned steeples of unequal height, was built for Marblehead Catholics, who settled initially in the Shipyard area. Father Daniel Healy officiated at the dedication ceremony of the yellow and white church on June 18, 1876. Fifty-three years later, in 1929, a new and larger cruciform-shaped granite church was built on Atlantic Avenue across from Seaside Park. (Courtesy Stephen J. Schier.)

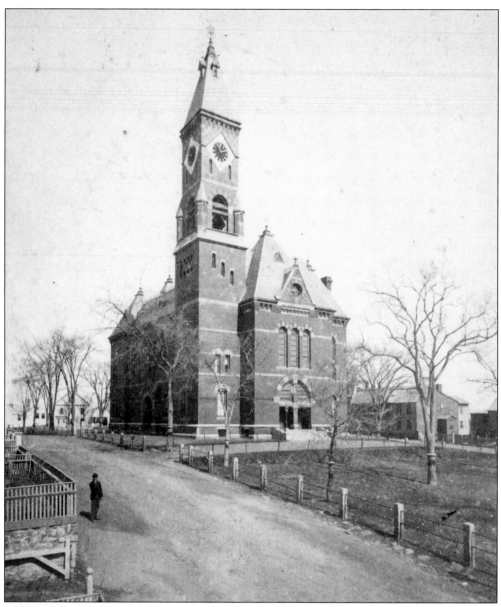

Abbot Hall, Washington Square, built 1876–77 (photographed c. 1880). The $100,000 bequest of Benjamin Abbot, a local man who made a fortune as a cooper (barrel-maker) in Boston, enabled the town to hire Boston architects Lord & Fuller to design this High Victorian structure. And high it sits (164 feet to the top of the weather vane) adjacent to Training Field Hill. Plain red-and-black-glazed brickwork with carved brownstone and granite details were used to enliven the public building, whose cornerstone was laid on July 25, 1876. Town offices are located on the first floor, where the walls are adorned with local-history murals painted during the Public Works of Art Project in the 1930s. The Selectmen's Meeting Room contains not only *The Spirit of '76* but related paintings of Revolutionary War events, an oversize bronze bust of Elbridge Gerry, the town flag with its seal, the 1924 bell from the U.S. naval cruiser *Marblehead*, and the Town Deed, the town's oldest document, drawn up as an agreement with Native Americans on July 14, 1684. (Courtesy McGrath collection.)

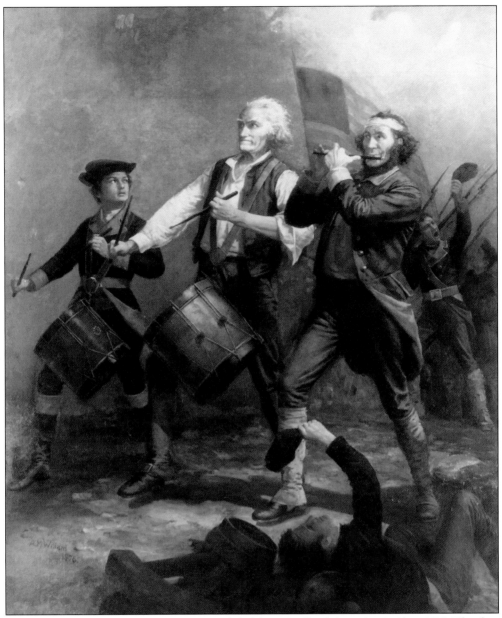

The Spirit of '76, oil on canvas by Archibald M. Willard (1836–1918), 1876. The first stop most tourists make in Marblehead is Abbot Hall, where they have no trouble finding one of the best-known historic American paintings, *The Spirit of '76*, an impressive 8-by-10-foot canvas (not including the gilded frame). The painting was originally titled *Yankee Doodle*. The non-academic artist used his father as a model for the central figure of the older man leading the trio while beating a drum; the fifer was Willard's friend Hugh Mosher; and the drummer boy was the son of General John H. Devereux of Cleveland, Ohio. Four years after the painting was displayed in Philadelphia at the 1876 centennial exhibition, General Devereux donated it in the hope that it be "erected in Abbot Hall to the memory of the brave men of Marblehead who have died in battle on sea and land for their country." (Courtesy Marblehead Board of Selectmen.)

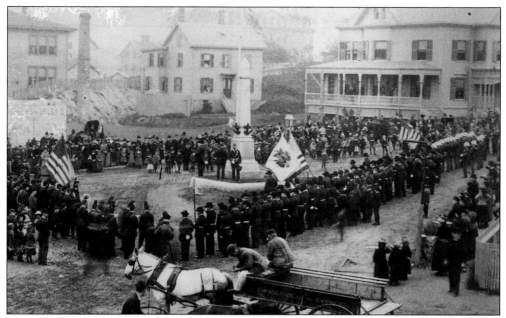

Dedication of the Mugford Monument, junction of Pleasant and Essex Streets (photographed 1876). The smaller of two commemorative obelisks carved of Hallowell, Maine, granite and dedicated in 1876 prompted the greatest celebration in Marblehead up to that time. The 18 1/2-foot monument was dedicated to the memory of Captain James Mugford Jr. on the centennial of the Revolutionary War hero's death. Fortunately the monument escaped the great fire of the following year, and in 1912 it was moved to the summit of Old Burial Hill. (Courtesy Mr. and Mrs. Richard Slee.)

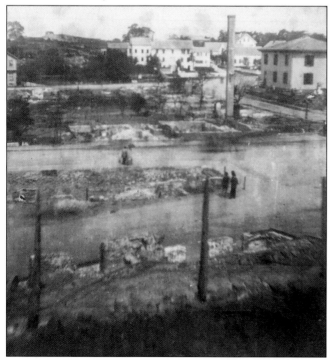

Aftermath of the great fire (photographed 1877). There had been scattered fires in eighteenth- and nineteenth-century Marblehead, but the first of two almost back-to-back conflagrations wiped out the manufacturing center of the town and the income of most of the inhabitants. The devastating fire of June 25, 1877, started in a stable at the rear of a hotel near the Lynn Shoe Factory. This stereopticon view shows the burned district as viewed from Nicholson Hill with the Sewall School and the end of Cornish Lane, now Evans Road. (Courtesy Marblehead Historical Society.)

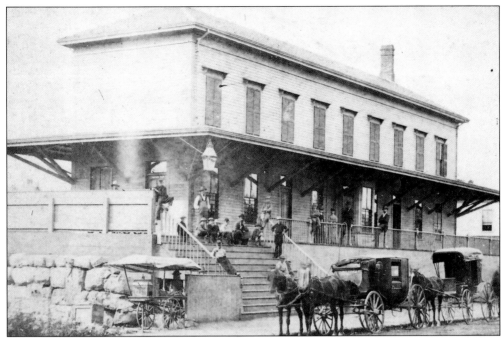

Third railroad station, Pleasant Street, built c. 1878 (photographed c. 1880). The wide, overhanging roof of the elevated, wood-framed depot shelters waiting passengers while the horse-drawn cabs await the steam locomotive and other passengers. A lonely peanut vendor, with his cart near the foot of the stairs, hopes for business. The second great fire (1888) destroyed this train station and the second generation of wooden shoe factories in the area. (Courtesy Wilkinson collection.)

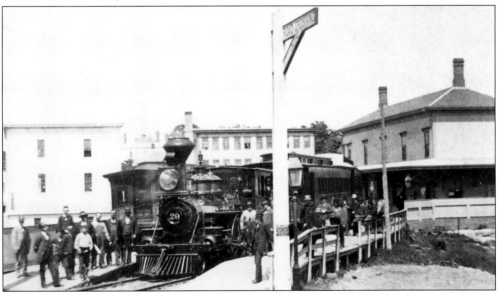

Steam locomotive #29 at the third train station (photographed c. 1880). Nicknamed "The Tiger," this powerful steam engine was built in South Boston in 1854 for $6,000. It is preparing to depart from the ramp at the rear of the station near the tall road-crossing sign. (Courtesy Wilkinson collection.)

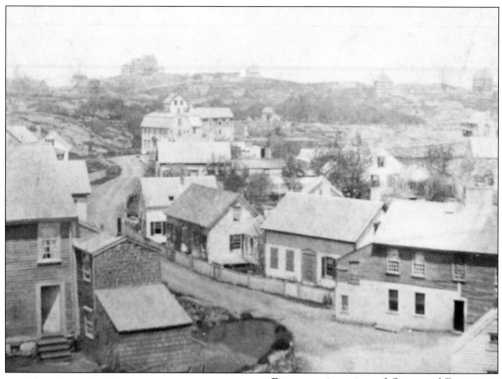

Barnegat, junction of Orne and Beacon Streets (photographed c. 1880). A serpentine dirt road follows the harbor in the oldest section of Marblehead, still affectionately referred to by locals as Barnegat, an ancient name with a clouded history. The earliest "fishery," as the town's fishing operation was known, was located here in the early seventeenth century. The road to the right leads to Little Harbor, a well-protected, attractive anchorage. (Courtesy McGrath collection.)

The Honorable Samuel Roads Jr. (1853–1904.) The distinction of being the town's first tour guide probably goes to the late-nineteenth-century dapper gentleman whom "Some time ago the summer people invited . . . to pilot them around Marblehead and environments, pointing out the principal places of historic interest." A drummer in the Civil War, Roads grew up listening to stories about his hometown and incorporated them, along with original research, in his outstanding work *The History and Traditions of Marblehead*, published in 1880. (Courtesy Chadwick collection.)

The Cloon family goes to market (photographed c. 1882). Members of the Cloon family are being driven by William Martin in the business wagon owned by the William F. Cloon Hardware Company at 86 Washington Street. They pause at the Gun Artillery House, still situated at 45 Elm Street across from the Gerry School. The Federal-period arsenal was built in 1808. (Courtesy McGrath collection.)

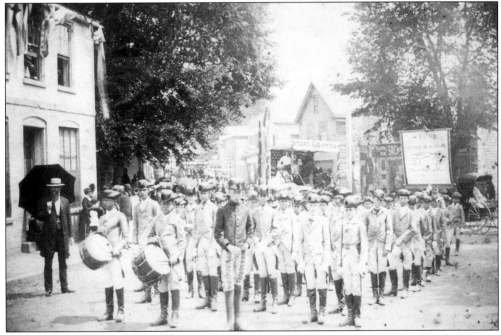

Story Grammar School Continentals at parade rest (photographed July 4, 1884). These young soldiers, wearing smart uniforms and tricorn hats, pause near the intersection of Washington and Hooper Streets to be photographed. The group is followed by the school's float and those of other organizations in the town's largest and finest parade to celebrate the signing of the Declaration of Independence. Holding an umbrella is "Seed King" and philanthropist James J.H. Gregory. (Courtesy Marblehead Historical Society.)

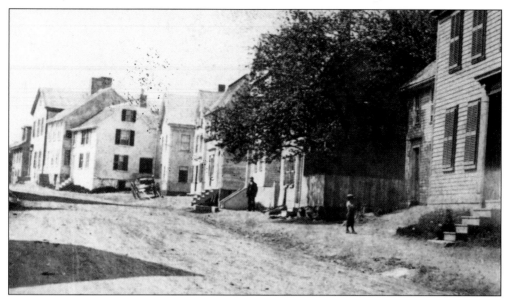

Mugford Street looking toward Elm Street (photographed c. 1885). The steeple of the former (1832) Second Congregational Church, Unitarian, cast a long, thin shadow across unpaved Mugford Street until October 1, 1910, when the church was destroyed by fire. A new church in the Colonial Revival style, believed to have been inspired by a South Carolina building, was built in the site by June of the following year. (Courtesy Wilkinson collection.)

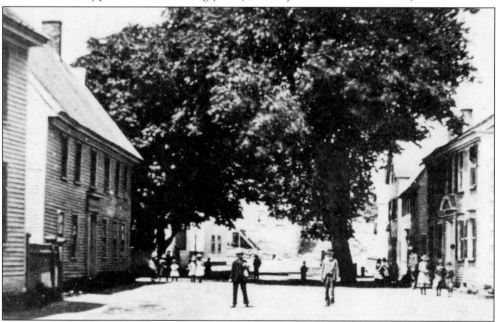

Franklin Street looking toward Washington Street (photographed c. 1885). Long-gone elm trees tower over the c. 1663 Ambrose Gale House with its steeply pitched roof and later door pediment on the left side of Franklin Street (no. 17), and shade the 1764 Georgian home of shoreman Joseph Homan (no. 16). The corner quoins and segmental arch doorway of the latter dwelling, known as the Devereux House, give it architectural distinction. (Courtesy McGrath collection.)

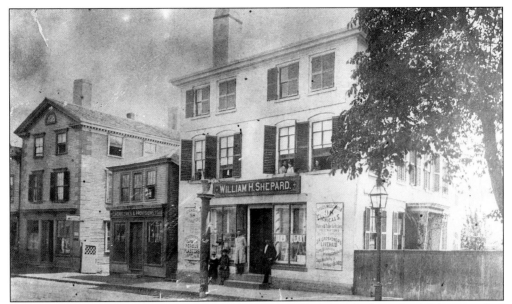

William H. Shepard's apothecary shop, 98 Washington Street, built c. 1785 (photographed c. 1885). The Lemmon family owned this brick Georgian house in 1885. In order to open a rival apothecary business, William Lemmon forced Shepard's preexisting shop to relocate along with his family, some of whom are probably peering out of the second-story windows. Shepard bought the small building next door and renovated it to make a better store (see p. 119). The mortar-and-pestle trade sign on the free-standing column is of interest, as are the signs flanking the display windows. (Courtesy Chadwick collection.)

Patent medicine advertisement (c. 1886). Richard Bessom's name appears under two headings in the business directory for 1886: "Grocers" and "Patent Medicines." His shop at 79 Front Street was near the Town Wharf. (Courtesy Swift collection.)

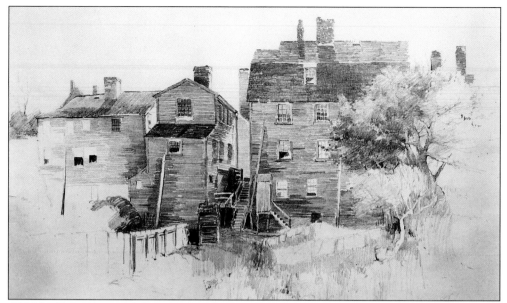

Old Marblehead, pencil drawing by Charles Herbert Woodbury (1864–1940), 1887. Lynn native Charles H. Woodbury was an observant and accomplished artist as well as a dedicated lifelong art teacher. He made at least one similar pencil drawing of Marblehead houses the year he had his first one-man exhibition at a Boston gallery, where thirty paintings were sold. (Courtesy Boston Public Library, Print Department.)

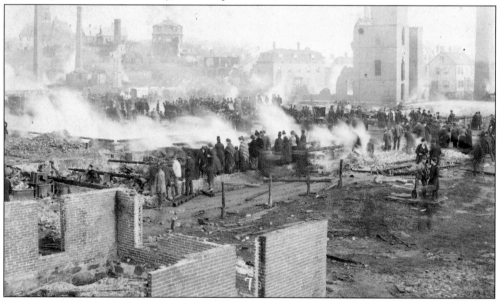

Marblehead's Conflagration, Dec. 25, 1888. Spectators huddle in groups, unable to believe that a second major fire could take place in the same area a little more than a decade after the disastrous fire of 1877. This action photograph was taken "while the ruins were burning, Dec. 26" by Worden's Instantaneous Photos, 48 Winter Street in Boston. The fire, which started with an explosion around 10 pm on Christmas Eve, destroyed fifty important buildings at an estimated value of $600,000; some two thousand people were left without work. (Courtesy Louise Graves Martin Cutler.)

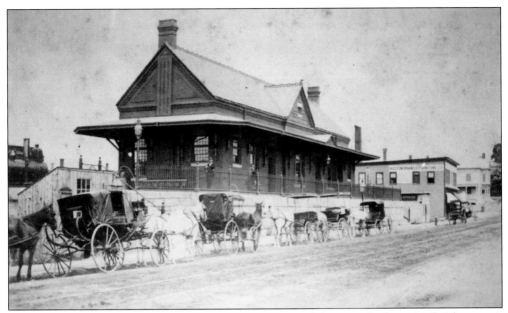

Fourth railroad station, Pleasant Street, built 1889–90 (photographed c. 1890). The town's fourth and final railroad depot was built on the site of the three previous wooden structures. After the second great fire of 1888 the town fathers ordered that all new construction in the downtown area be made of masonry; therefore, the gabled slate roof of the Boston & Maine Railroad Depot had brick walls. In the building were two large waiting rooms, a ticket office, and a baggage room. (Courtesy Wilkinson collection.)

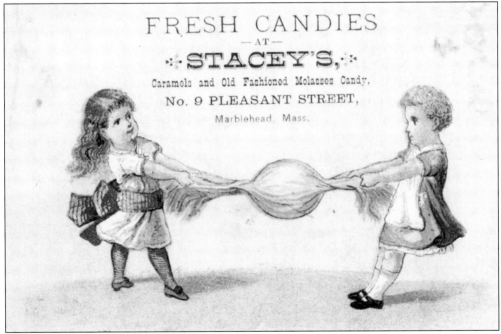

Confectionery manufacturer's advertisement (c. 1890). Girdler Stacey's "FRESH CANDIES" and other assorted sweets could be purchased at his store in the Odd Fellows' Hall building next to the Baptist church on Pleasant Street. (Courtesy Swift collection.)

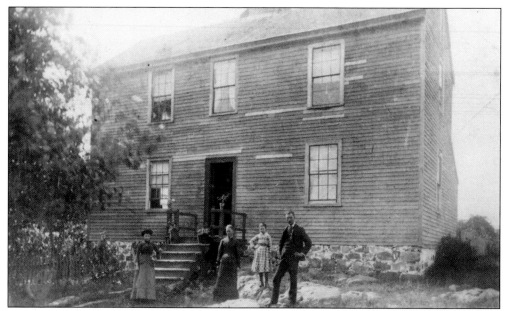

Captain Thomas Peach House, 16 Beacon Street, built before 1740 (photographed c. 1888). The death of sprightly Captain Peach in 1802 was mentioned in the chatty diary of Salem's Dr. William Bentley, who wrote that he saw the centenarian "going on foot to Boston on Election day & saw him soon after actually in Boston." Peach's brother Joseph later purchased the house for £600. Mrs. Sarah R. Griffiths owned the property when this photograph was taken, and George B.W. Griffiths, a shoe-laster who boarded at the house, may be the gentleman with arms akimbo. (Courtesy Mr. and Mrs. William R. Creamer.)

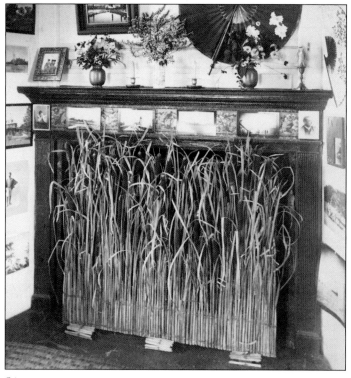

Detail of the parlor chamber in the Peach (Griffiths) House (photographed c. 1885). The cat-o-nine-tails display set into the hearth resembles decorative French-inspired topiary planters popular today. Vases of fresh flowers were tastefully arranged on the mantelpiece to complement the pictures, prints, and accessories. (Courtesy Creamer collection.)

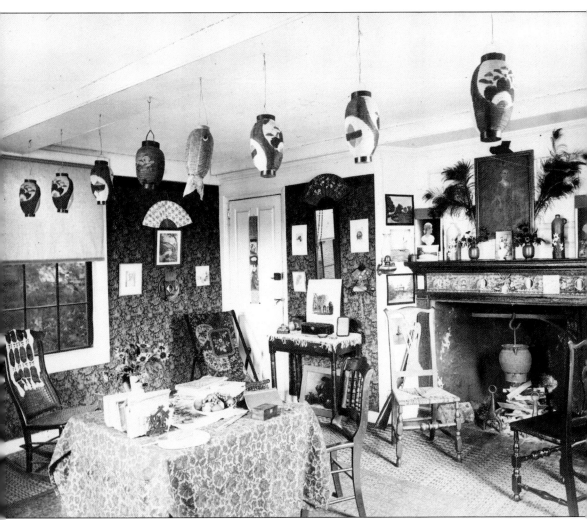

Parlor chamber in the Peach (Griffiths) House, 16 Beacon Street (photographed c. 1885).
This accompanying photograph was also taken during the High Victorian period, when the Griffiths family resided in the Colonial house. Mrs. Sarah R. Griffiths might have decorated the second-floor room where, amid the clutter with a decidedly Japanese flair, an oil portrait of an unidentified boy hangs over the Federal-period mantelpiece. This painting, the whereabouts of which is unknown, is attributed by the author to the Boston artist Joseph Badger (1708–1765), who painted portraits of members of Salem's Pickering family in the 1740s. (Courtesy Creamer collection.)

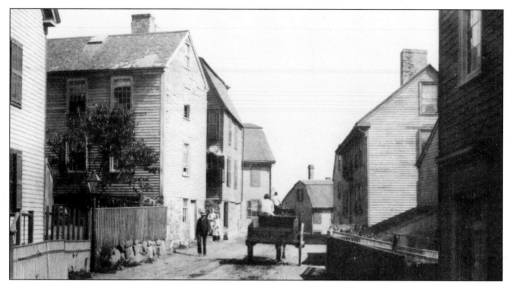

Lee Street looking toward Union Street (photographed 1890). A horse-drawn wagon travels along unpaved Lee Street flanked by some documented houses, including (from left to right): #9 Lee Street (where the unidentified family is standing), built by 1736 for the fisherman John Bassett; #2 Union Street (the so-called "Lafayette House"), begun in 1731 for the merchant George Minot and finished for another merchant, Major John Palmer; and #6 Lee Street (the house with the chimney, far right), built in 1721 for shoreman John Searl. The Searl House was later the home of Captain Nicholas Broughton, commander of the *Hannah*, the first American naval vessel to be commissioned by General George Washington. (Courtesy Parker collection.)

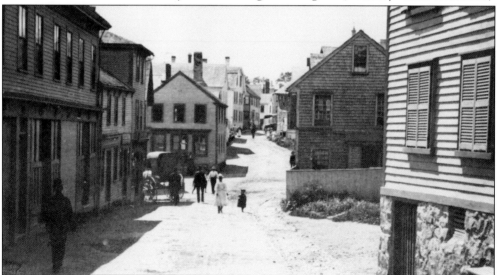

Front Street looking toward the intersection of State Street and the Town Landing (photographed 1890). A portion of the Three Cod Inn (*c.* 1680) on the corner of Glover Square, is visible at the right. Allegedly, shots fired in 1775 from the British frigate *Lively* struck a side of the tavern. All the buildings on the left side of Front Street are no longer standing. Ceramics made by the Marblehead Pottery were sold out of a shop at 111 Front Street between 1915 and 1936. The former Graves Yacht Yards replaced the row of wooden buildings in 1940. (Courtesy Parker collection.)

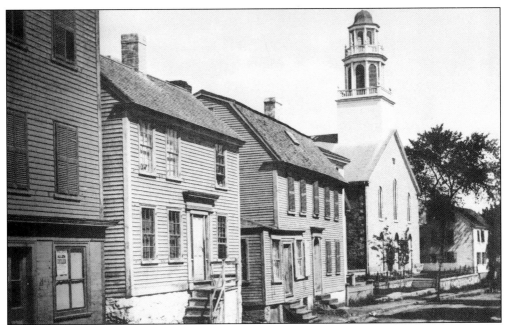

View of Washington Street and the Old North Congregational Church (photographed 1890). Wood-framed colonial dwellings flank the 1825 granite facade of the First Church of Christ, Congregational, whose parish was gathered in 1635. The Sir Christopher Wren-inspired octagonal steeple has urn finials, and the domed cupola is surmounted by a gilded codfish weather vane, a religious and secular motif popular in seaport towns and cities. The gambrel-roofed house at 47 Washington Street, with the nineteenth-century corner store addition, was built c. 1744 for the shoreman Richard Homan, and is referred to by locals today as the Hawkes House. (Courtesy Parker collection.)

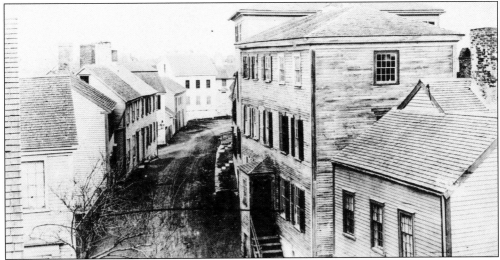

Front Street looking toward Darling Street (photographed c. 1890). This charming streetscape shows pitched, hipped, and gambrel-roofed dwellings with their predominant chimneys. Darling Street intersects Front Street where the house with the corner street lantern appears. Folk artist J.O.J. Frost lived in the house behind the fence in the center of the photograph, at 54 Front Street, between 1894 and 1899. (Courtesy Cuzner collection.)

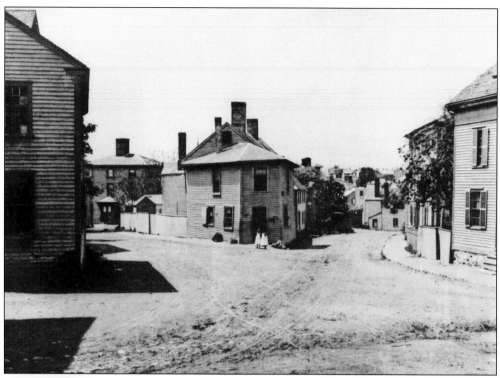

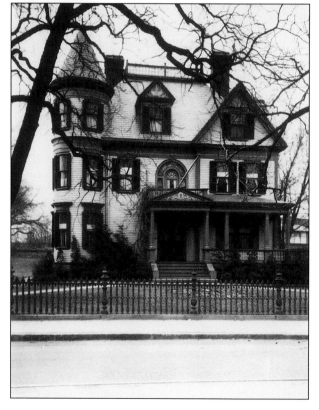

"The Flatiron," at the junction of South and Middle Streets (photographed 1891). Subtitled "An Old Relic of Marblehead," this photograph of streets bifurcated by "The Flatiron" reveals some of the clustered charm of the colonial town. Two girls in white smocks stand at the intersection of South (left) and Middle Streets. (Courtesy Parker collection.)

William Neilson Jr. House, 65 Pleasant Street, built c. 1890 (photographed c. 1900). This turreted and gabled Queen Anne-style house was erected opposite the Odd Fellows' building next to the new post office (built 1905). No longer standing, this attractive residence was later home to John Lancey Jr., a leading shoe manufacturer. In 1923 it was sold to William Koen, owner of the Salem Theater. (Courtesy Marblehead Historical Society.)

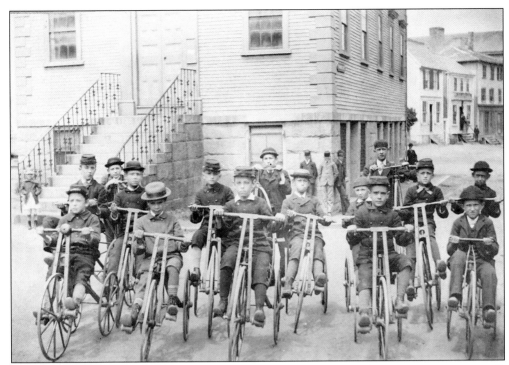

Young tricyclists at the Old Town House (photographed c. 1890). Fifteen boys posed, not too happily, for this group photograph, taken at the front entrance of the Old Town House. Six youngsters sport navy-blue or cadet-gray military caps called "kepis," a French military type of headgear used during the Civil War, and evidently later. (Courtesy Ellen Neily Antiques.)

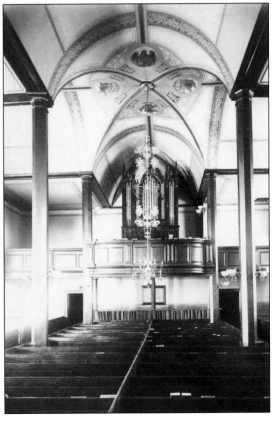

Interior view of St. Michael's Episcopal Church, 26 Summer Street (photographed c. 1890). The interior of the 1714 church had been recently renovated when this photograph was taken, and the gilded and polychrome decoration on the vaulted arch ceiling was subsequently removed. Still in place, however, is the twelve-branch brass chandelier engraved by its Italian maker, J. Gallo, as "the gift of John Elbridge, Esq. of ye City of Bristol, 1732." The highly decorative hanger was made of wrought iron and then gilded to complement the luster of the chandelier. (Courtesy Cummings collection.)

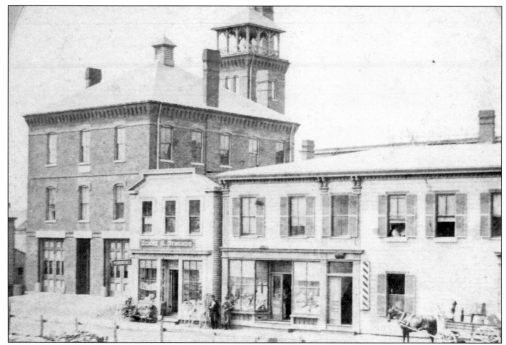

Brick Steamer House, with a view of School Street **(photographed c. 1890).** Merrill H. Graves, whose book and stationery shop was located at 111 Washington Street, sold this stereoscopic view and many others of Marblehead as a sideline to his business. This is an early image of the new firehouse at 10 School Street, built of brick seven months after the great fire of 1888. Henry O. Symonds operated the hardware and fancy-goods store in the small building next door. (Courtesy Maurais collection.)

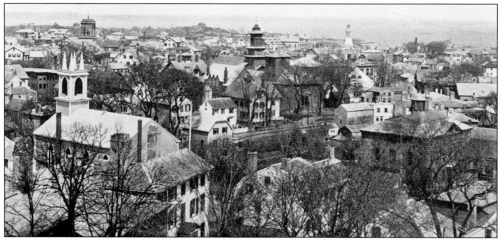

Panoramic view from Abbot Hall tower (photographed c. 1895). Different religious groups in town built three of the four churches shown in this late-nineteenth-century picture. From left, they are as follows: St. Stephen's Methodist Church, 26 Summer Street (1833); Second Congregational Church, Unitarian, 28 Mugford Street (1832); and the First Baptist Church, 17 Pleasant Street (1868). At the right is Old North Congregational Church, 41 Washington Street (1825). The cupola on the Lee Mansion is a landmark in the right corner of the photograph. (Courtesy McGrath collection.)

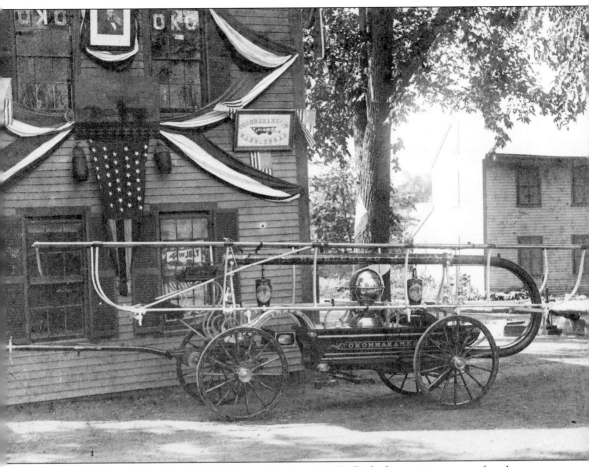

Okommakamesit hand-engine (photographed c. 1895). Early fire engines were often known as hand-engines as they were pulled by the hands of the volunteers who operated them. The earliest hand-engine in Marblehead was the "Friend," ordered from England in 1751 by Robert "King" Hooper. During the nineteenth century the M.A. Pickett, the Phoenix, the Liberty Hose, and the Washington Hook and Ladder companies were colorful attractions at firemen's musters in town. The company with the most unusual name, the Okommakamesit, still maintains its hand-engine along with a hose reel and related fire-fighting equipment in a small building at the lower intersection of Washington and Middle Streets. Built in 1861 in Pennsylvania, the "OKO" was photographed in its shining glory on a Fourth of July in the late nineteenth century. A photograph or print of Abraham Lincoln was displayed on the headquarters above a mid-nineteenth-century folk art painting of a horse and wagon. A pair of leather fire buckets, flags and bunting, and a pertinent poster in the first-floor window all proclaim the patriotic holiday. (Courtesy Cutler collection.)

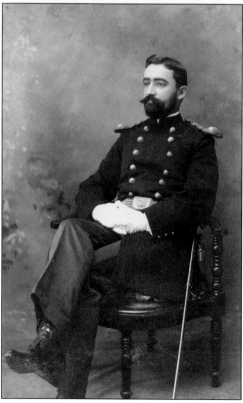

Tom "Teat" Rhoades Jr. and two friends at the Beach Comber's Dory Club (photographed 1898). This picture was taken the day before young Tom, the fireman's son, left Marblehead for Cuba to fight as a private in the Spanish-American War. The small building with the sign served as the meetinghouse for the dory club members; the large warehouse behind it, which was painted red, was used to store fish. Tom is shown with Mrs. Lefavour's cows in the backyard of the buildings located on lower Front Street across from Fort Beach. (Courtesy Marblehead Historical Society.)

Captain Charles Ackley Slee (photographed c. 1897). This confident young man, dressed in full uniform with sword at his side, was named commanding officer of the Marblehead Light Infantry in 1896. The following summer, when the United States cruiser *Marblehead* entered the harbor for a six-day visit, Captain Slee chose the last evening to invite the crew to a dance in their honor at the armory of the Marblehead Light Infantry on Atlantic Avenue. (Courtesy Kenneth C. Turino.)

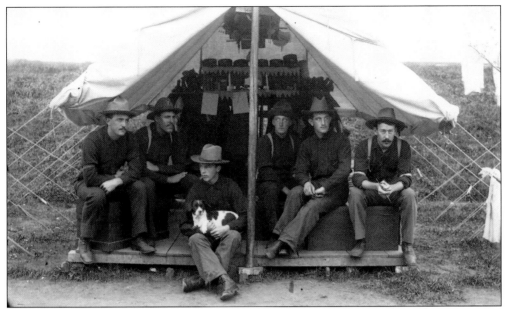

Spanish-American War soldiers at Fort Sewall (photographed 1898). These unidentified soldiers from Company C in Chelsea, Massachusetts, are relaxing on bivouac at Fort Sewall in 1898, the last time the harbor embankment was used by the military. The well-stocked tent has caps, boots, assorted supplies, and at least two candles on shelves with decorative serrated paper edging. (Courtesy Cutler collection.)

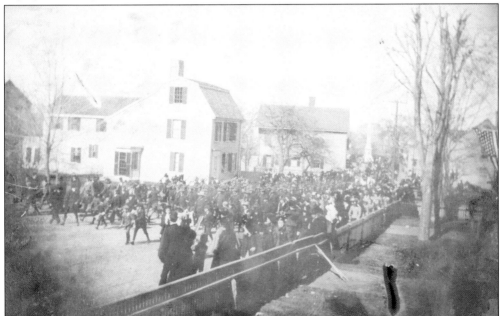

Company C's return parade along Elm Street (photographed April 17, 1899). The less than four-month-long Spanish-American War was declared by Congress on April 21, 1898, and ended on August 12. This blurred historic photograph was taken when the Eighth Regiment company returned from the Cuban campaign to a welcoming reception in Marblehead. (Courtesy Cuzner collection.)

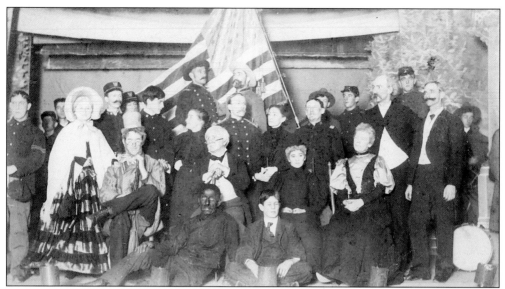

The Drummer Boy (photographed c. 1895). This Civil War play may have been an early production at the Squash House. Before being moved to 59 Elm Street in 1856, the shingled structure had stood on Gerry Island, where it was built in the early 1700s. Mr. and Mrs. Harold D. Hodgkinson restored the building and then rented it to a theater group headed by Harmon McGregor. The Squash Players performed here for a number of years before Edward N. Holden acquired the structure and carried on the dramatic tradition. (Courtesy Schier collection.)

Fliegel-Fladger family (photographed c. 1899). The first Jewish family to settle in Marblehead, the Fliegel-Fladgers shown here are Harris Fliegel-Fladger (left), Rebecca Fliegel, and Barnet Fliegel. The family lived at 10 Central Street in the Shipyard area. Barnet and Rebecca had seven children, the oldest of whom, Abraham, continued to live at the same address after his marriage. Abraham's five children attended the Roads School at the time he had an automobile sales and repair garage. The Fliegels moved to Beverly, Massachusetts, by 1930. (Courtesy North Shore Jewish Historical Society.)

Benjamin Franklin Martin Sr. family (photographed 1897). Upon hearing that President William McKinley (1897–1901) approved of large families, B.F. Martin Sr. gathered his brood for this photograph taken in the backyard of their home at 100 Elm Street and sent it to the president, requesting the position of postmaster in his hometown. Martin won the post in 1898. From left to right are as follows: (front row) John Hooper, Stephen, Mrs. Martin (Mary Eliza Woodfin), the postmaster, Robert, and Joseph; (back row) Henry, Benjamin Franklin Jr., Mary Eliza, Lawrence, George, and Knott Vickery. (Courtesy Cutler collection.)

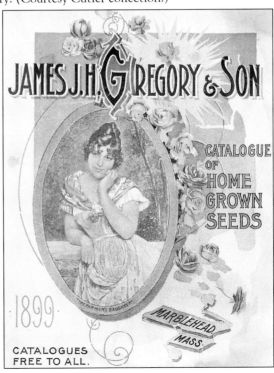

James J.H. Gregory & Son seed catalogue for 1899. Thrice married but without children of his own, James John Howard Gregory (1827–1910) wrote that he aspired "to be a useful citizen in my native town and content with being the largest vegetable farmer and seed grower in New England." His philanthropy, which resulted from his lucrative business as a seedsman, enabled the "Seed King" to donate Bailey's Headland, off Orne Street, to the town for a park. (Courtesy Maurais collection.)

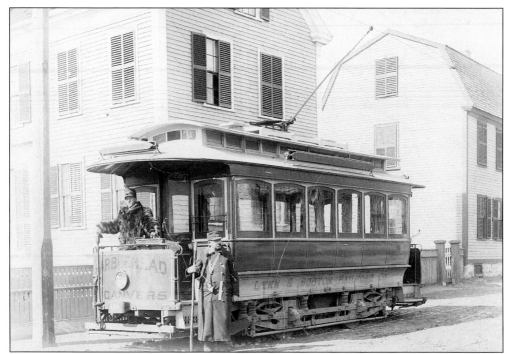

Waiting for passengers (photographed c. 1899). Conductor Augustus L. Atkins and Motorman William A. Carey, both employed by the Lynn & Boston Railroad Company, patiently await their fares. The trolley's last run on this line was in 1935; two years later the Marblehead-Salem service ended, the electrically powered vehicles being replaced by buses. On January 23, 1895, Marblehead was illuminated by electricity for the first time. (Courtesy Chadwick collection.)

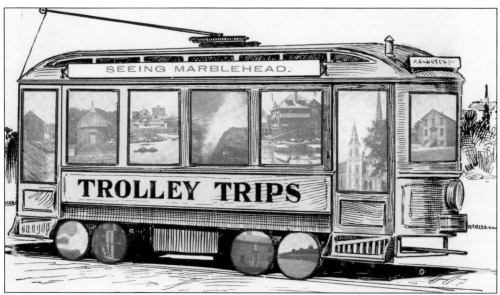

Trolley Trips (c. 1899 postcard). A pen-and-ink sketch of a generic electric trolley with vignettes of town sites on the windows, doors, and wheels must have been a popular postcard around the turn of the century. (Courtesy Maurais collection.)

Four

Peach's Point

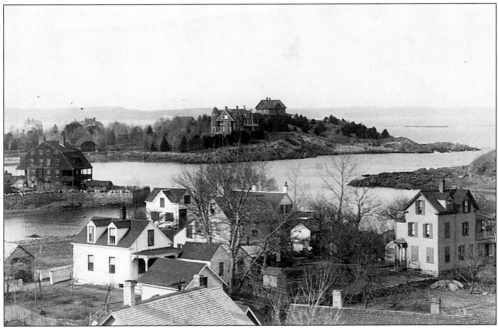

Peach's Point as seen from Barnegat (photographed c. 1895). The private peninsula in Marblehead known as Peach's Point, first inhabited in the 1630s by the Englishman John Peach, was for almost 250 years used chiefly for farming. Boston businessman Francis B. Crowninshield saw the possibilities of this unspoiled land, so in 1871 he purchased a large section of the point. The following year he built the house to the right on the highest elevation for his family. Seaside Farm, the largest house on Peach's Point, was constructed before 1898 and was razed c. 1969 to make way for a smaller, more manageable residence. The large gambrel-roofed and shingled house on Doliber's Point (in the middle distance) was built on land owned by Grace Oliver, whose name was later given to the nearby beach. Brown's Island, also called Crowninshield Island (at the right), was donated by Louise DuPont Crowninshield to the Trustees of Reservation for conservation purposes. (Courtesy Mr. and Mrs. James R. Hammond.)

Road to Peach's Point (photographed c. 1890). The verdant entrance to the grand summer estates reveals sections of two of the houses on the promontory. Francis B. Crowninshield's residence is partially visible at the end of the dirt road, and the former Seaside Farm is shown at the right before the first-floor rounded bay window was added. (Courtesy Marblehead Historical Society.)

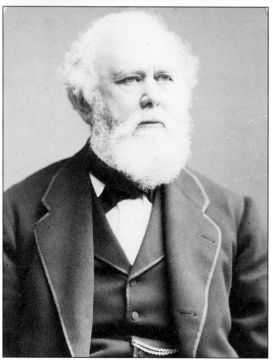

Francis Boardman Crowninshield (1809–1877). Mr. Crowninshield's farsightedness enabled succeeding generations of his family to enjoy unparalleled vistas from their home. (Courtesy Hammond collection.)

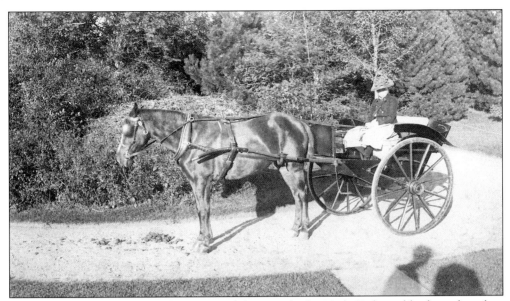

Emily Crowninshield in her horse cart (photographed 1891). Fashionably dressed twelve-year-old Emily, the sister of Benjamin W. and Frank "Kino" Crowninshield, was more than likely photographed by one of her parents. (Courtesy Hammond collection.)

Benjamin Williams Crowninshield (photographed c. 1905). The grandson of Francis B. Crowninshield affected a very serious Edwardian image for this studio picture taken in Boston, where he lived in an H.H. Richardson-designed house at 164 Marlborough Street. B.W. Crowninshield resided in Marblehead each summer and in Boca Grande, Florida, in the winter during his later years. (Courtesy Hammond collection.)

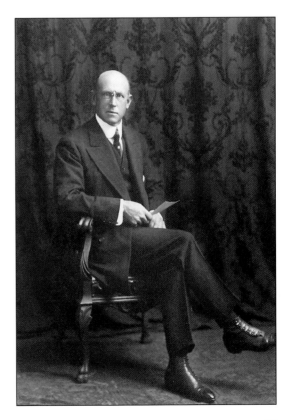

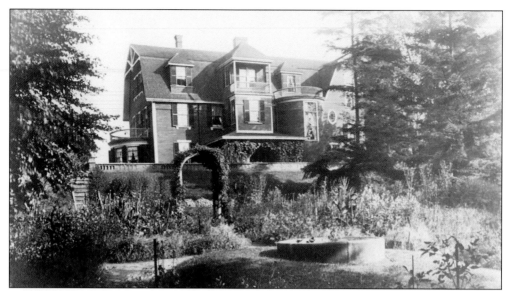

Seaside Farm and garden (c. 1935 postcard). This immense house was used only during the summer by Mr. and Mrs. Francis Boardman Crowninshield. "Kino" was a great yachting enthusiast, and Louise DuPont Crowninshield, from Winterthur, Delaware, was a noted historic house devotee. (Courtesy Hammond collection.)

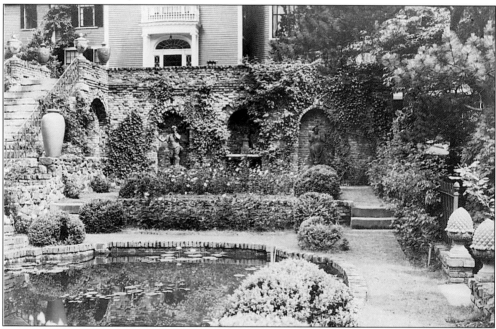

Seaside Farm garden (photographed c. 1940). Relatives and friends of the Crowninshields could walk leisurely down the wide stairs opposite the front entrance of the farm past swagged urns of European manufacture, and see the serpentine-shaped lily pond surrounded by lush greenery. A grotto-like environment was created by the ivy-covered brick arches with almost-life-size neoclassical figures in naturalistic poses. This garden and terrace at the east side of the house had a spectacular view of Brown's Island and the harbor. (Courtesy Hammond collection.)

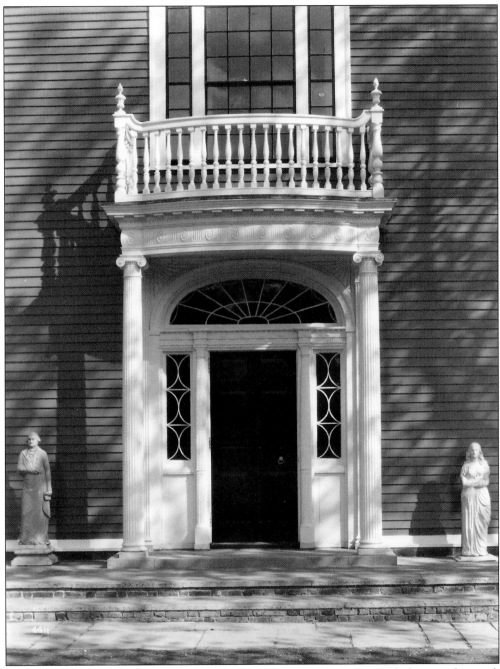

Main entrance of Seaside Farm (photographed c. 1940). A professional photographer took this dramatic picture of the Neoclassic front entrance with a fan-shaped window and balustraded portico before the doorway was donated to the Trustees of Reservation and the house razed. The cast-iron stovetop figures of George and Martha Washington were probably made at the Mott Iron Works in New York around 1860. (Courtesy Hammond collection.)

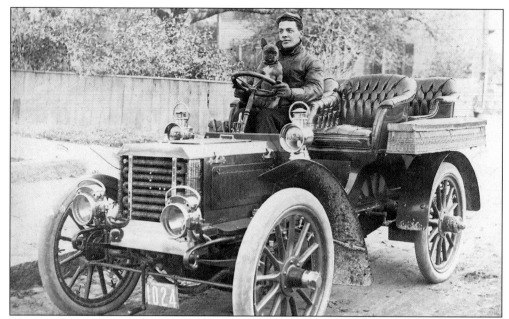

Waiting for the family (photographed c. 1905). The Crowninshields' pet dog was more focused on the photographer than was family chauffeur Ralph Caviliere when the two posed in the large-wheeled Pearless with its tufted leather seats and wicker carrying cases. (Courtesy Hammond collection.)

Louise DuPont Crowninshield and a young relative (photographed c. 1920). The older sister of Henry Francis DuPont, of Winterthur, Delaware, was also enamored of American decorative arts, but not with the same passion as her consummate collector brother. Mrs. Crowninshield, known to many of her relatives as Aunt Louise, was especially benevolent toward the Lee Mansion. She was involved with the Marblehead Historical Society from the late 1930s until her death in 1958, and because of her "taste and generosity the Lee Mansion was furnished appropriately for its period." (Courtesy Hammond collection.)

Five

The Early Twentieth Century

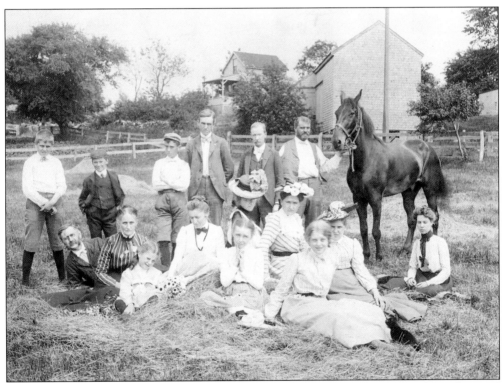

Relatives and friends at Naugus Head (photographed c. 1900). Finely dressed members and friends of the Parker and Swasey families enjoy a summer day in a pasture at Naugus Head, which overlooks Salem Harbor. Martha Elizabeth Parker is seated in the foreground, and Fred Litchman, who photographically chronicled Marblehead's people and places during the late nineteenth and early twentieth centuries, is standing next to the unidentified gentleman holding the reins of the horse. (Courtesy Cuzner collection.)

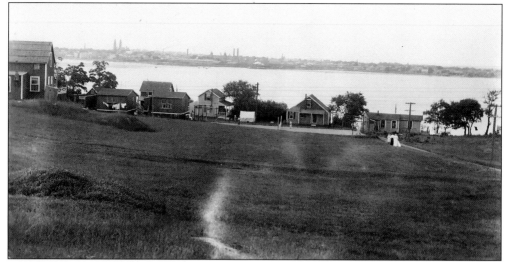

Naugus Head looking across Salem Harbor (photographed c. 1900). Naugus Head was the site of Fort Darby, built after 1629, and of the Fort Darby ferry, the earliest ferry in Marblehead, which began service to Salem in 1637. Not many permanent houses were built in the farming area until the late nineteenth century, when the area became a popular location for summer cottages, picnics, dancing, and watching fireworks. Electricity enabled the occupants of the cottages to enjoy an easier lifestyle, although outhouses were still prevalent. (Courtesy McGrath collection.)

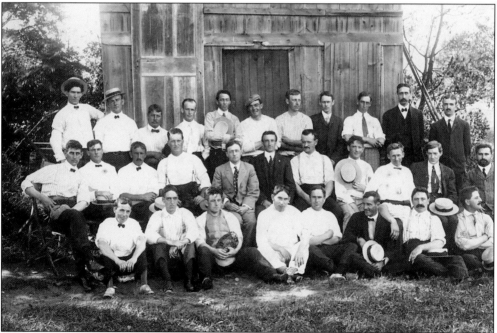

Baseball team at Naugus Head (photographed c. 1900). Three tiers of well-dressed young men, both mustachioed and clean-shaven, appear in front of the men's clubhouse somewhere along the shore. Among the mainly unidentified players and friends are William O. Doherty (standing to the right of the open door) and Knott V. Martin (seated fourth from the left in the middle row). (Courtesy Cuzner collection.)

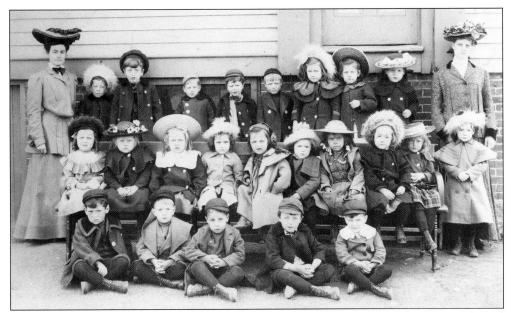

Kindergarten school picture (photographed 1903). These well-behaved youngsters dressed in winter clothing are flanked by their teachers, Martha E. Parker (right) and an unidentified woman. The Maple Studio took this photographic record of the following students, from left to right: (front row) Luther Martin, Herbert Dale, Lewis Peach, William Woodfin, and Willie Blackford; (middle row) Elmira Williams, Myra Snow, Emma Shepard, Alice Rogers, Marion Roads, Elsie Knight, Florence Burridge, Madeline Brown, Ruth Powers, and Madelyne Dixey; (back row) Raymond Smith, Jessie Lent, Fred Lyons, Leonard Woodfin, Gerald Magee, Edith Hinkley, Alice Homan, and Emma Cuthbert. (Courtesy Cuzner collection.)

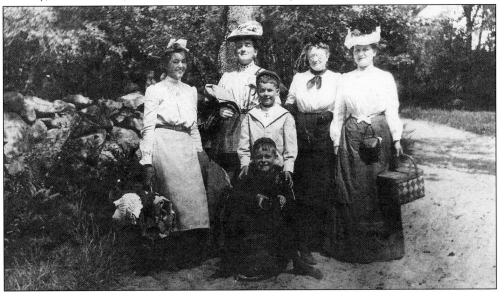

Off for a picnic (photographed c. 1902). Slee family members and the unknown photographer (probably Charles A. Slee) are dressed in Edwardian style for a summer picnic. Bella Hardy Slee, holding a picnic basket at the right, was Charles' wife, and Ackley Roads Slee, in the foreground, his son. (Author's collection.)

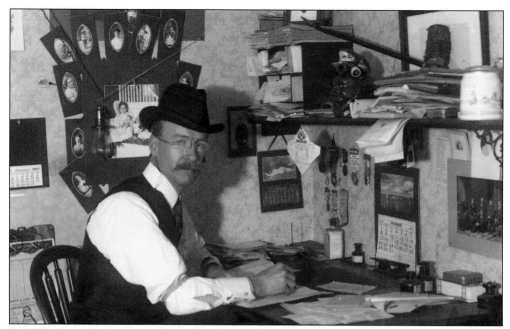

Fred Brigham Litchman at his office desk (photographed 1902). Born in 1869, Litchman established his first photography shop in 1898 on State Street. Specializing in commercial photography, he dealt in Eastman Kodak supplies and worked as a book and job printer. In 1914 Litchman moved his business and residence to 157 Washington Street. An official photographer for the Boston & Maine Railroad, Litchman may have taken a self-portrait in the corner of his office filled with photographs, calendars, and papers. (Courtesy Cutler collection.)

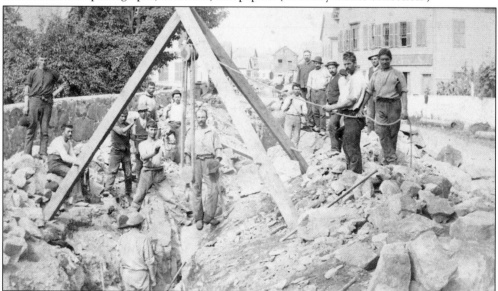

Laying water pipes on Back Street (photographed c. 1903). A wooden triangular device was used by this work crew to install water pipes along Back (now Elm) Street. Some of the new pipes are leaning against the fence in front of James J.H. Gregory's Seed House on the right. The land behind the stone wall at left became the site of the Squash House, which was later moved there from Gerry Island in 1856. (Courtesy McGrath collection.)

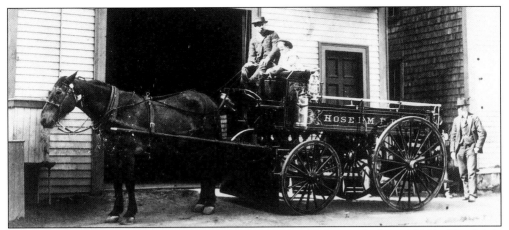

Hose wagon No. 2, Franklin Street Engine House (photographed c. 1902). The M.A. Pickett hand-engine was housed in the wood-framed Victorian building before the arrival of this painted hose wagon, built by the firm of Abbot & Downing in Concord, New Hampshire, in 1901. The organization of the hose companies in 1899 put an end to the volunteer fire departments. (Courtesy Marblehead Historical Society.)

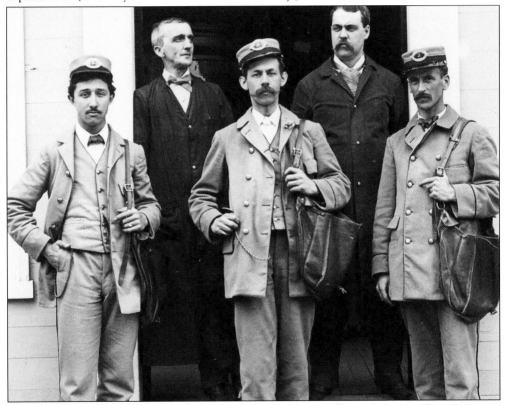

Post office employees (photographed c. 1904). A truncated pyramid of post office clerks and mail carriers stand ready to sort and deliver the daily mail. Clerks Sam Proctor and Thomas Eastland are on the threshold, while the one identified mail carrier, Wallace D. Weed (appointed in 1897), is at the right. Free mail delivery began in Marblehead in 1863. (Courtesy Wilkinson collection.)

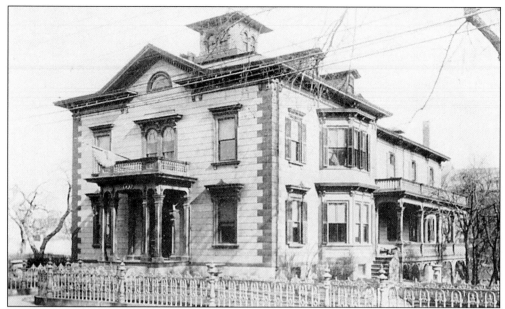

Atlantic Lodge, No. 55, 62 Pleasant Street, built c. 1875 (photographed c. 1918). The second Odd Fellows' Hall building was the former Victorian home of shoe manufacturer John F. Harris. With a little imagination one can see a prototype for the facade of this house in the Lee Mansion, built slightly over a century earlier in 1768. (Courtesy Cuzner collection.)

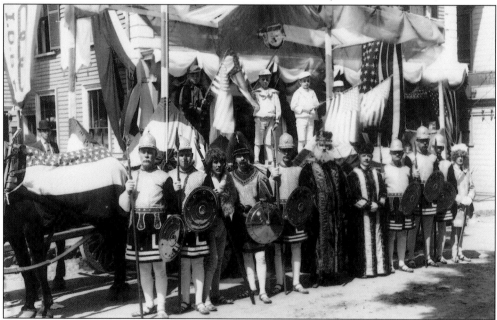

International Order of Odd Fellows float in front of its headquarters, 9 Pleasant Street (photographed July 4, 1903). Court pages wave banners over the king and members of his retinue before the start of the Fourth of July parade. Inspiration for a float of this kind may have been derived from a Mardi Gras illustration in a periodical. The trade sign on the Grader Building next door informed passersby of Girdler Stacey's confectionery store. (Courtesy Cutler collection.)

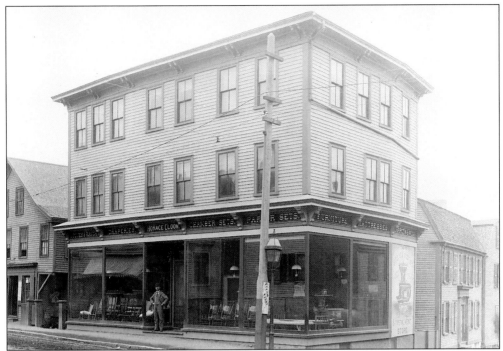

Horace Cloon's furniture store, 84 Washington Street (photographed before 1904). At the corner of Washington Street (Ye Queen's Highway in 1739) and State Street (King Street in 1729), Horace Cloon advertised his home furnishings above large plate-glass windows. Streets in town were first illuminated with gas in 1854. (Courtesy Chadwick collection.)

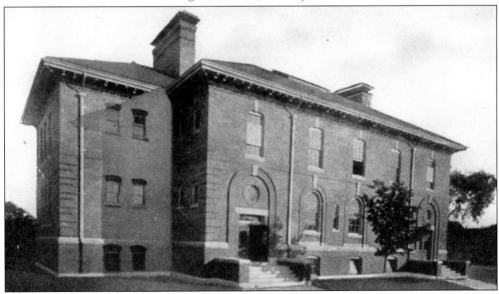

Roads School, 26 Rowland Street, built 1904 (c. 1910 postcard). Elongated keystones puncture the molded brickwork of the first-floor arched windows and doors of the grammar school on Prospect Hill named in honor of Marblehead's most noteworthy historian, Samuel Roads Jr. Early and memorable teachers included Edith Bray, Margaret Casey, Mildred Goldsmith, and Nelly McCloskey. (Courtesy Maurais collection.)

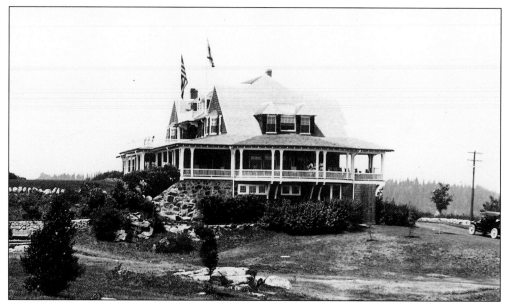

Tedesco Country Club, Tedesco Street, built 1904 (photographed c. 1906). The surname of a female Cuban opera singer of the mid-nineteenth century who performed in Boston was chosen for this golf club, which was incorporated in 1903. Sixty-nine members joined the first year; they and their families enjoyed a golf tournament on the six-hole course in July, a clambake on the shore, and of course, camaraderie, all for $25 each! Three disastrous fires leveled the successive clubhouses; the present structure was built in 1953. (Courtesy Tedesco Country Club.)

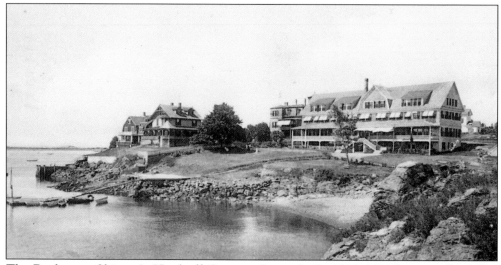

The Rockmere, Skinner's Head off Gregory Street, built 1901 (1905 postcard). Called "the best summer hotel" by its many guests, the largest resort ever built in Marblehead was reconstructed in 1905 by owner Gilbert Brackett, and his family. An unsurpassed view of the harbor, well-maintained gardens, and other amenities made the ninety-four-room watering hole a popular destination between its opening and the Great Depression. The enormous anchor is now the only visual reminder of the grand hotel, which was torn down in the spring of 1965 to make way for the Glover's Landing complex. (Courtesy Swift collection.)

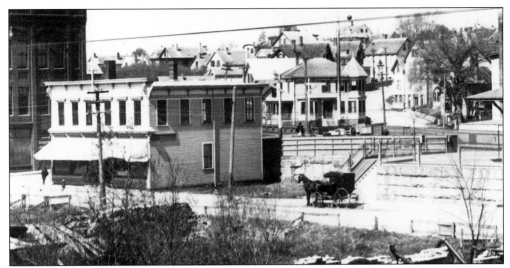

Pleasant Street near the corner of School Street (photographed c. 1905). The ruins of buildings destroyed by the fire of 1888 are on what became Memorial Park. Businesses in the four-story Rechabite Building (left) included the New England Telephone and Telegraph Company. Nat Wadden had a dry goods store in the box-shaped building, and the Unitarian church parsonage was located in the turreted house on Sewall Street in the 1890s. A horse-drawn cab stands next to the baggage chute of the fourth train station, built of brick the year following the fire. (Courtesy Wilkinson collection.)

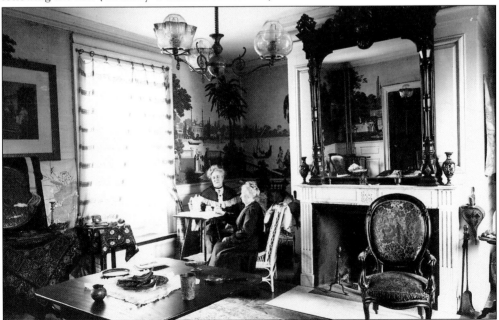

Edwardian tea party (photographed c. 1905). Two Marblehead matrons enjoy tea and conversation in the sunny corner of an unidentified Georgian house. The imposing overmantel panel is almost concealed by the Renaissance Revival mirror resting on a slim mid-nineteenth-century marble mantelpiece. Federal-period polychrome French wallpaper in an East Indian design established the major pattern in the room, with later textiles and artfully arranged accessories conveying a late-Victorian atmosphere. (Courtesy Mr. and Mrs. Norris Bull Jr.)

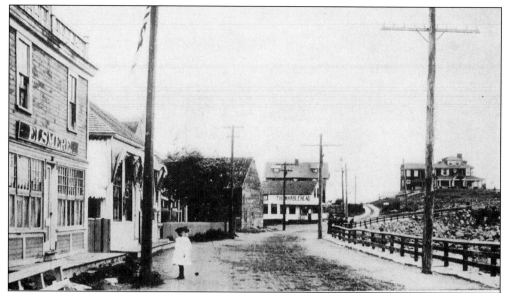

"Fort Beach, Showing Old Fish House," (c. 1905 postcard). The Old Fish House is the gabled-ended structure seen earlier in the photograph of Tom "Teat" Rhoades Jr. with cows. This large fish-drying and storage warehouse was located at the site of the present small parking lot and turnabout. The wooden fence along Front Street leads to Fort Sewall; hence the name for the pebbly cold-water beach opposite these buildings. (Courtesy Swift collection.)

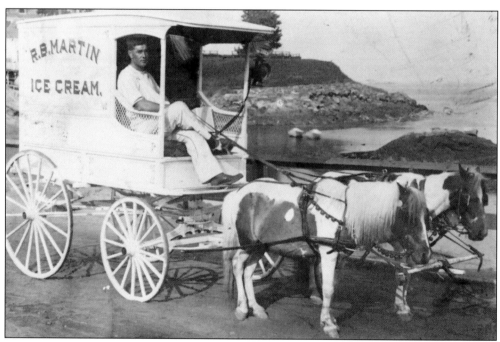

"Ice cream!" (photographed c. 1905). Robert B. Martin is in a relaxed pose, probably enjoying the view alongside Fort Beach while waiting for parents to buy ice cream cones for their demanding children. The attractive white-painted wagon is pulled by a pair of Shetland ponies named Solomon and Red and White. (Courtesy Cutler collection.)

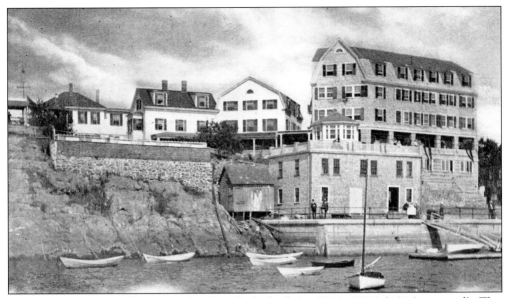

New Fountain Inn, adjacent to Crocker Park, built in 1904–1905 (1906 postcard). This gabled hostelry perched on the rocky shoreline had its name carried over from the early-eighteenth-century Fountain Inn on Bailey's Head in Barnegat. Professor Henri Umberhau managed the New Fountain Inn; later the name was changed to the Harbor Inn when Isaac Anderson and Mrs. Allan Higgins became the new owners. The white houses were the residences of the Snow family, and the little fishing shanty partially built on stilts belonged to Josh Witham. (Courtesy Swift collection.)

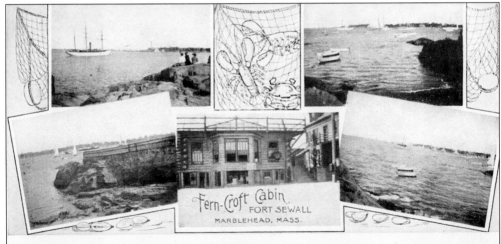

Dear Sir :— Marblehead, Mar. 15, 1907.

Fern-Croft Cabin will open April 1st, 1907 fully equipped in every way to maintain the enviable reputation the **Cabin** has attained of furnishing the finest Fish and Chicken Dinners on the Atlantic Coast. Come and let us prove it. Lobster served in every style. We cater to Private parties. Several Private dining rooms. Telephone connection and Electric Lights. E. M. BEVINS, Proprietor.

Fern-Croft Cabin, Front Street (1907 postcard). Constructed in the log cabin style across from Lovis Cove, this restaurant was the most unusual one on restaurant row, near the last trolley stop on Selman Street. On the lower floor the waiting room presented vaudeville acts for one penny. (Courtesy Swift collection.)

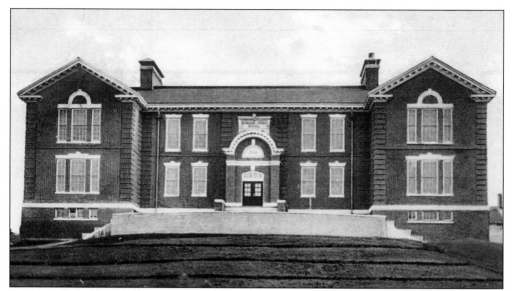

Gerry School, 50 Elm Street, built 1906 (c. 1910 postcard). Named in honor of Elbridge Gerry, this grammar school, situated on a hill, still provides public elementary education. Some early teachers who remain as fond memories include Carrie Merritt, Marion Cruff, and Beryl Brewerton. The first principal, Mary Looney, "a sweet, kindly woman," was also a full-time teacher. (Courtesy Swift collection.)

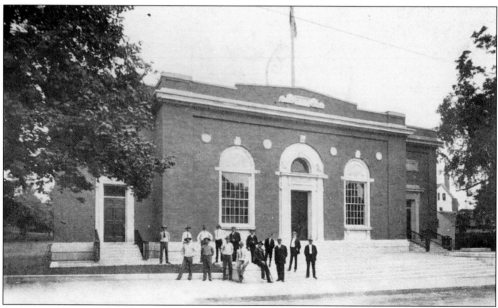

Second Post Office and Custom House, 61 Pleasant Street, built 1905 (1906 postcard). The town's handsome new post office replaced the one in rented space in the Odd Fellows' Hall building on the same street. The Colonial Revival brick structure proudly displays eagles above the pilasters flanking the front entrance, the scales of justice above a key in the left roundel, and a post rider on a horse in the right roundel. Postmaster B.F. Martin is the seated gentleman with a cane. (Courtesy Swift collection.)

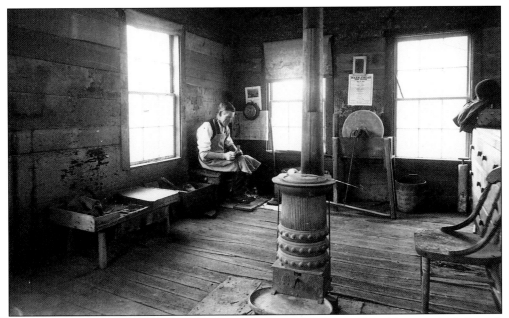

Marblehead "heeltapper" at work (photographed 1908). The small building in which Patrick "Patsy" Lyons lived and worked at 116 Front Street is referred to as a "ten-footer" and the profession he chose was cordwainer, or shoemaker. The Humphrey Coal Company supplied the 1908 calendar on the wall behind the clock and probably coal for the centrally located stove. Several ten-footers, including this one, still exist in town; they can be seen on Tucker and Mason Streets and near the entrance to Fountain Park off Orne Street. (Courtesy Chadwick collection.)

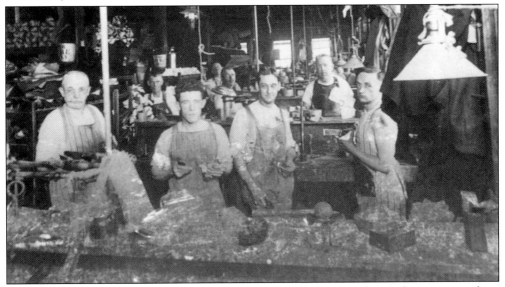

Interior of a shoe factory (photographed c. 1906). Wearing heavy-duty aprons, these shoeworkers were probably photographed in the Clark Shoe Factory, which was located on Green Street until it was destroyed by fire in the late 1930s. The two men in the center of the foreground table are James Devine and Arthur H. Shirley; Thomas Sinclair is the older man in the second row to the left of Mr. Devine. (Courtesy Joan von Sternberg.)

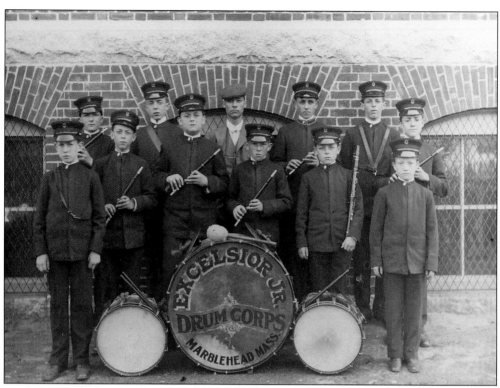

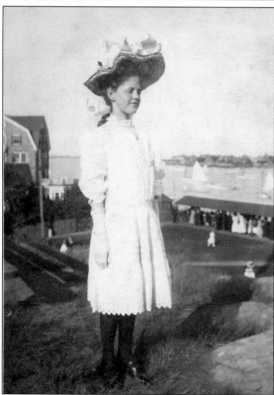

Excelsior Junior Drum Corps (photographed c. 1908). Though none too cheerful when the photographer snapped their picture by the Roads School, the drum corps could make townspeople smile and cheer when they passed in a parade. The group was organized August 25, 1906, and reorganized on March 3, 1910. (Courtesy Schier collection.)

At the top of Crocker Park (photographed July 4, 1909). This twelve-year-old, with her large, fashionable hat, white hair ribbon and dress, and high-buttoned black shoes, is a picture-perfect representation of the Edwardian period. She is enjoying Independence Day near the summit of Crocker Park, with its grand views of the harbor and the Neck, the causeway, and the Atlantic Ocean beyond. Uriel Crocker gave most of the land on Bartoll's Head to the town in 1886, making it the first public park in Marblehead. (Courtesy Swift collection.)

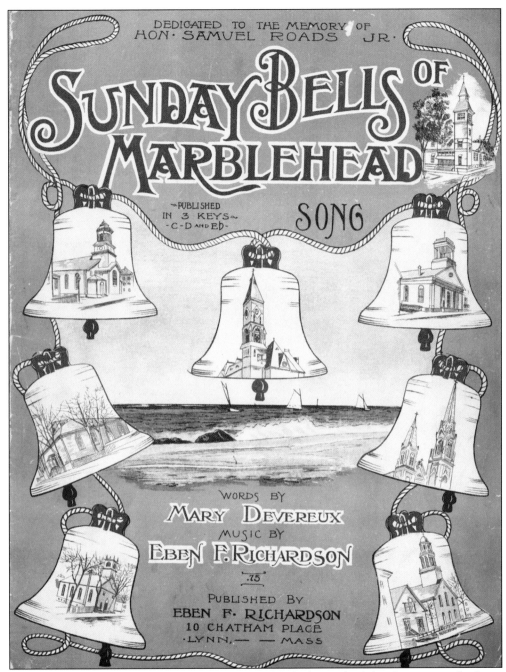

"Sunday Bells of Marblehead," sheet music (published 1907). A local woman and a Lynn man collaborated to create this two-stanza melancholy song dedicated to the memory of Marblehead's beloved historian. Ecclesiastical vignettes fill the outer bells, while the center bell has a line drawing of the tower of Abbot Hall, which houses the bell donated by town philanthropist James J.H. Gregory. (Courtesy Chadwick collection.)

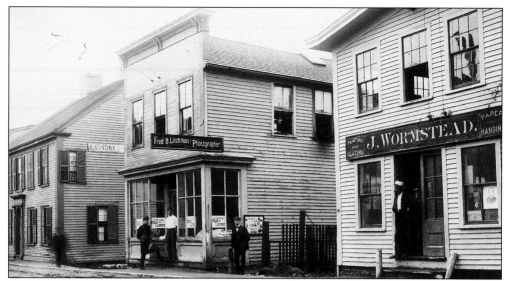

Three State Street businesses (photographed *c.* 1907). These proprietors of two adjacent buildings on the mainly residential street are George H. Peach Jr., standing in the doorway of the Marblehead Steam Laundry (no. 15); Fred B. Litchman, the photographer with his hand on a post; and Joseph S. Wormstead, a painter, glazier, and paperhanger standing in the doorway of 11 State Street. (Courtesy Chadwick collection.)

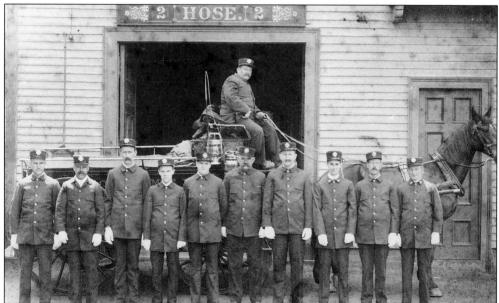

Formal firemen's photograph (*c.* 1908). Ten firemen stand at attention in their dress uniforms, with white gloves, in front of a horse-drawn hose wagon at the Franklin Street Engine House, built in 1886 for the M.A. Pickett Engine Company. Some gear is stored behind the seat of driver Bill "Luggy-do" Hammond, and the fire alarm box at the station is partially visible above the rear of the wagon. From left, the firemen are Lewis Pedrick, Christy Burridge, Billy Chamberlain, Rob Hammond, Henry Martin, Jacoby Stacey, Bill "Kaiser" Atkins, William "Hucko" Sweet, Ben Sweet, and Charlie Stacey. The horse's name was Boston. (Courtesy Wilkinson collection.)

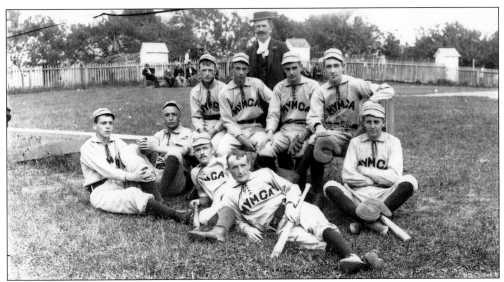

Marblehead YMCA baseball team (photographed 1908). Three outhouses on private property are visible behind this relaxed group of young baseball players, accompanied by their manager or coach. The Backstreeters, the Barnegaters, the Devereux A.C., and the Shipyarders were also popular baseball teams in the early twentieth century. The town's first football game was played against Ipswich in 1909, with Raymond O. Brackett as head coach. (Courtesy Cutler collection.)

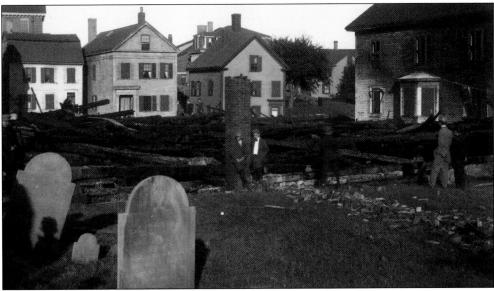

Aftermath of the fire that destroyed the Second Congregational Church, 28 Mugford Street (photographed October 2, 1910). This photograph of dwellings on Mugford Street was taken from the cemetery the day after the fire. The church was built in 1832, around the same time as the Greek Revival house across the street, second from the left (no. 19). The back windows of this house look toward the Gerry School on the hillside. The house at the far right with the bay window (no. 14) was the residence of brothers George H. and William E. Laskey. A new Colonial Revival church was built on the fire site the following year. (Courtesy Wilkinson collection.)

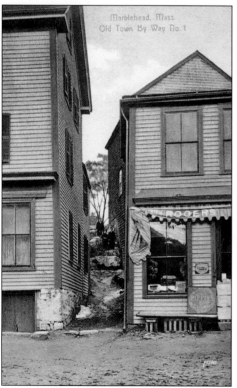

Archie S. Knight and some old salts (photographed c. 1910). This group of "Headers" (with younger friend Archie at the far left) poses on the steps of photographer Willard Jackson's fishing shanty, once located at Fort Beach off Front Street. At male gatherings such as this, yarns were spun about trips taken in earlier times to the Grand Banks fishing area and other destinations. Some local phrases favored by the salty set were "whip," "down bucket," and "to Hell I pitch it!" (Courtesy Knight collection.)

"Old Town By Way No. 1" Market Square (c. 1910 postcard). The way architecture often hugs the landscape in the Old Town (a term in use before realtors made it even more popular) is evident here, as are the steep stone steps connecting residential Mechanic Street with the Washington Street business district. Descending the steps are Eddie Holden, Russ Doliber, and Ray Fleet, some of the many children who took a short cut to the Gerry School. John S. Rogers owned the fruit store to the right, where he also sold penny candy, Coca-Cola, and other provisions. (Courtesy Swift collection.)

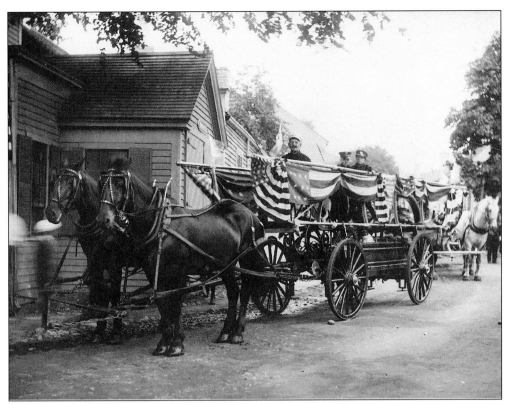

Firemen's muster parade (photographed c. 1910). Red-and-white bunting tastefully drapes the Okommakamesit hand-engine for this early-twentieth-century parade. The driver and three boys enjoy the ride through town, followed by the White Angel, an 1891 muster-only hand-engine from Salem, drawn by a team of white horses. (Courtesy McGrath collection.)

Charles A. and Ackley Slee, 3 School Street (c. 1910 postcard). Father and son pose in front of Mr. Slee's real estate office in the 1889 Gregory Building during a past winter season. Ackley grew up in town and later commuted by train to Boston, where he became a top executive at William Filene & Sons Company. (Author's collection.)

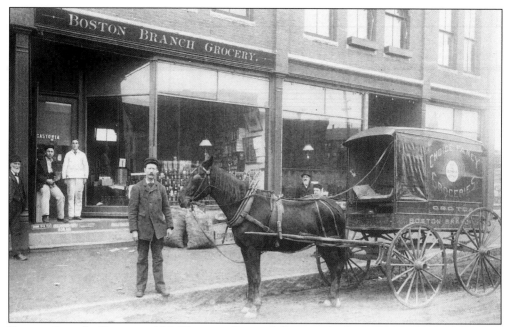

Boston Branch Grocery, 109 Pleasant Street (photographed c. 1910). An unidentified delivery man is about to depart from the grocery store in the 1889 Rechabite Building. The advertising labels on the steps resemble today's bumper stickers. (Courtesy Marblehead Historical Society.)

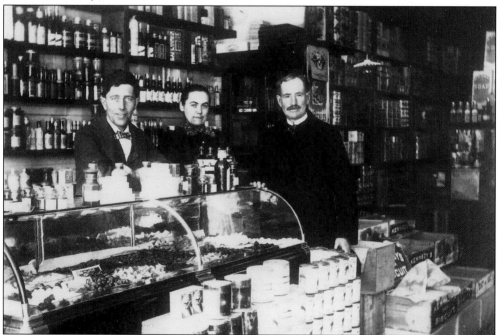

Employees of the Boston Branch Grocery, 109 Pleasant Street (photographed c. 1910). Jack Homan, Helen Munroe Wilkins, and an older gentleman (perhaps the proprietor) run a well-stocked grocery store featuring a mouth-watering variety of penny candy in the sparkling glass case. (Courtesy Marblehead Historical Society.)

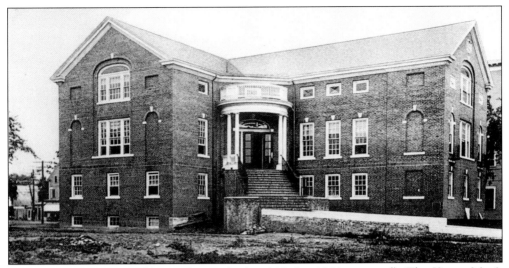

YMCA Building, 104 Pleasant Street, built 1910 (c. 1911 postcard). The Young Men's Christian Association moved from its former headquarters in the King Hooper Mansion to this new Colonial Revival structure built on the site of the Allerton Block, which had been destroyed in the 1877 fire. A semicircular balustraded portico serves as the main entrance to the L-shaped building, photographed before the landscaping of Memorial Park in the foreground. Some nineteenth-century shops on Atlantic Avenue are visible to the left. (Courtesy Swift collection.)

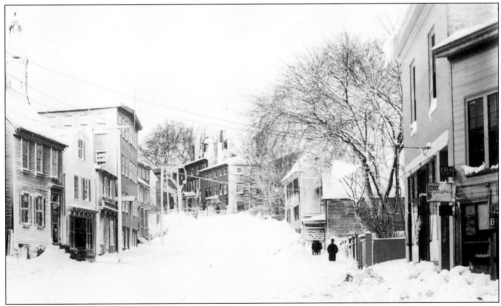

After a nor'easter winter storm, looking up Washington Street (photographed late nineteenth century). New England seaport towns and cities have always received more than their fair share of snow each winter. To be prepared for the dreaded season, one purchased "gents' furnishing goods" from Samuel Graves' clothing store at 171 Washington Street (the wooden building on the right, beyond the Lee Mansion fence). On the opposite side of the street, and during the opposite season, a person could buy or have a bicycle repaired at Blaney's Bicycle Store. (Courtesy Wilkinson collection.)

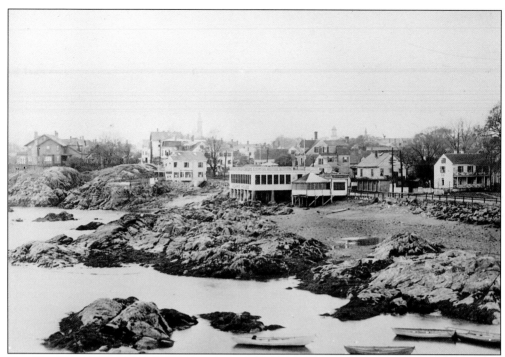

Fort Beach with the Adams House (photographed c. 1912). Front Street follows the rocky shore facing the popular restaurant and the smaller Rock Haven Sea Grill. Former fire chief John T. Adams built the restaurant, which honored his surname, in 1908, and had the one-story structure painted a pleasant yellow. Reasonably priced meals of fried fish and clams, or boiled lobster, kept the eatery bustling. At high or low tide these two restaurants were picturesque spots for seaside dining. (Courtesy Cuzner collection.)

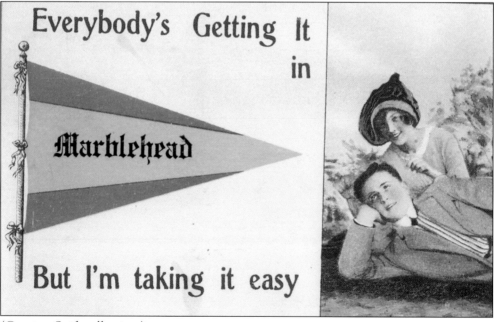

(Courtesy Swift collection.)

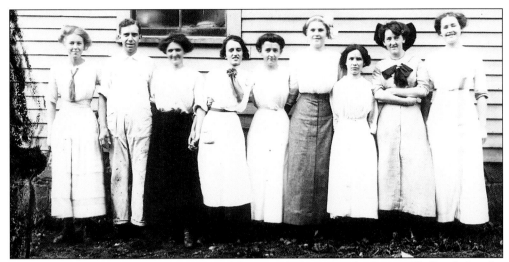

Peach's laundry girls, 15 State Street (photographed c. 1912). George H. Peach Jr., the owner of the laundry at this time, may be the gentleman shown here. The business moved to 7 Lincoln Avenue around 1915, and three years later an advertisement stated that the "wet wash department is a very busy place these days. The busy woman of the house finds it a great Wartime Economy. Our prices are very reasonable. Give it a Trial." (Courtesy Cutler collection.)

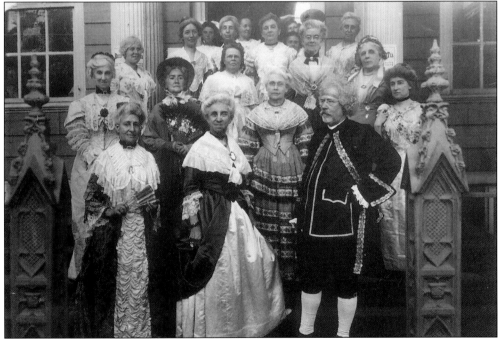

Prelude to a Colonial tea at the Lee Mansion (photographed 1913). Members of the Marblehead Historical Society pose to promote the Ye Old Colonial Days celebration. The two-day event was planned "to celebrate Marblehead's place in Colonial History," and it coincided with the 15th anniversary of the society's founding. The souvenir booklet informed guests that "as you sip your tea, and taste of the delicious seed cookies, pound cake and gingerbread such as grandmother used to make, it will seem like a return to the days of long ago." (Courtesy Marblehead Historical Society.)

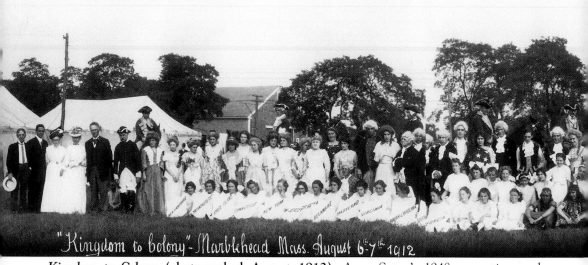

"Kingdom to Colony" - Marblehead Mass. August 6-7th 1912

Kingdom to Colony (photographed August 1912). Anya Seton's 1948 romantic novel *The Hearth and the Eagle* (set in old Marblehead) is still read today, whereas Mary Devereux Watson's 1899 similar historic novel, *From Kingdom to Colony*, is practically unknown. More popular in earlier years, it was presented as a pageant by the Marblehead Historical Society on August 6 and 7, 1912, at Humphrey's field in the Clifton section of town. The sentimental love

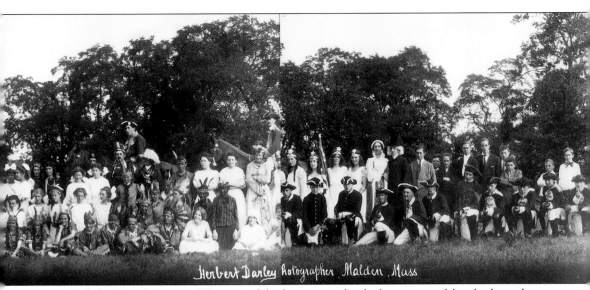

Herbert Darley Photographer, Malden, Mass

story of the Revolutionary War period had an exceedingly large cast of locals dressed as Colonials, Native Americans, and allegorical figures. The two-day pageant was described in a newspaper article as a "success dramatically as well as from a financial standpoint." Helen Paine Doane, who lived to be 107 years old, was the last surviving actress in the local extravaganza. (Courtesy Marblehead Historical Society.)

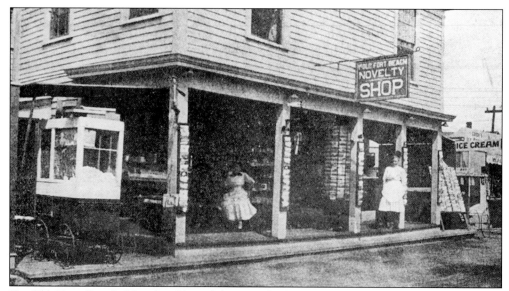

Ye Old Fort Beach Novelty Shop (photographed c. 1913). The open, walk-in look of this emporium invited curious passersby to browse through "all kinds of Imported fine china ware . . . in great varieties for Wedding Gifts and Whist Prizes, also a great line of Imported Post Cards and other Novelties." Rows of stacked postcards, many of which were printed in Germany, vied for attention between the popcorn wagon and the ice cream shop. (Private collection.)

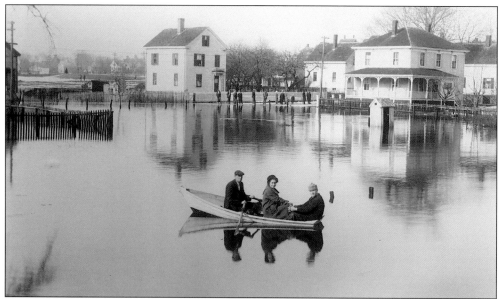

Flood in the Shipyard area (photographed March 1, 1914). Chestnut and Central, parallel streets between Atlantic Avenue and Walnut Street, became the scene of an unexpected flood after a heavy rain caused an underground sewer backup. A Mr. Collier and his younger friend, Dan Colbert, are rowing an unidentified woman to Atlantic Avenue to shop for provisions. The people standing along Chestnut Street are probably Irish Catholic neighbors, or "newcomers" as they were called, in contrast to the Anglo-Saxon Protestants who had always lived in the town. (Courtesy Marblehead Historical Society.)

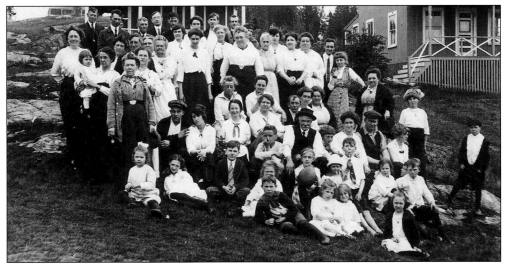

Lend-a-Hand Club at Bessom Beach (photographed c. 1913). Founded around the turn of the century, the Lend-a-Hand Club was a social organization whose members paid dues and, by doing so, helped fellow members in time of need. This large group enjoyed the day's outing at a member's cottage at Bessom Beach on the Salem Harbor side of West Shore Drive, near Nonantum Road. (Courtesy von Sternberg collection.)

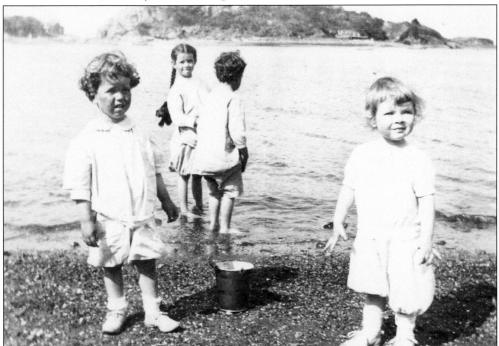

Children playing at Grace Oliver's Beach (photographed 1913). Evelyn F. Doherty (right) and three of her friends enjoy a sunny June day on the pebbly beach at Doliber Cove off Beacon Street. Brown's Island, in the background, is connected to the mainland by a strip of land and is accessible for half the period between high and low tide. During the early twentieth century, the male-only Heliotrope Club had a clubhouse on the island for its members. (Courtesy Cuzner collection.)

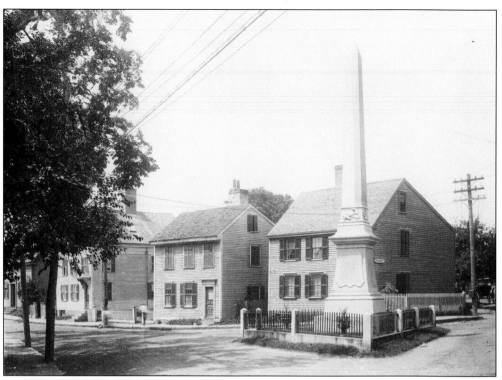

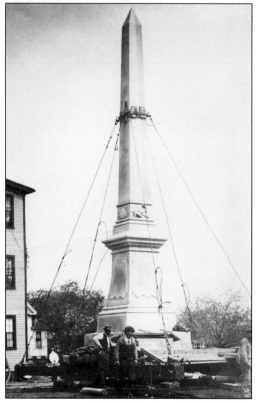

Soldiers and Sailors Monument, junction of Elm, Green, and Mugford Streets (photographed before 1913). The tallest of the three commemorative granite obelisks in town was erected on July 4, 1876, in memory of Marblehead soldiers and sailors who gave their lives in the Revolutionary War, the War of 1812, and the Civil War. In the background are two eighteenth-century houses on Elm Street, built around the time when the street was known as "ye highway on ye back side of ye town." (Courtesy Cutler collection.)

Moving the Soldiers and Sailors Monument (photographed May 1913). It took eight days to move the 34-foot obelisk on wooden rolling poles to its new location at the corner of Pleasant and Essex Streets, to be dedicated as Memorial Park. When turning one of the street corners, the foreman probably shouted the locally used phrase "Cut her Elbridge!" (Courtesy Cuzner collection.)

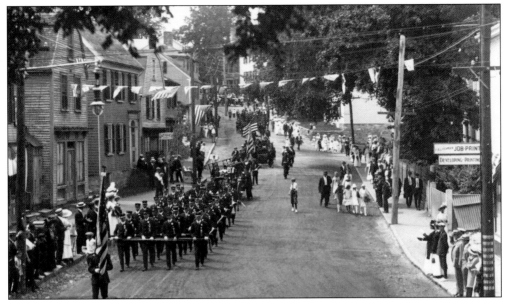

Decoration Day parade along Washington Street (photographed c. 1915). On what would be known today as Memorial Day, this parade featured marching groups, several hand-engines, local dignitaries, and veterans. John Ingalls Tucker, one of the last Civil War veterans (who died in 1937 at age ninety-four), would have ridden in a convertible such as the one near the top of the street. (Courtesy McGrath collection.)

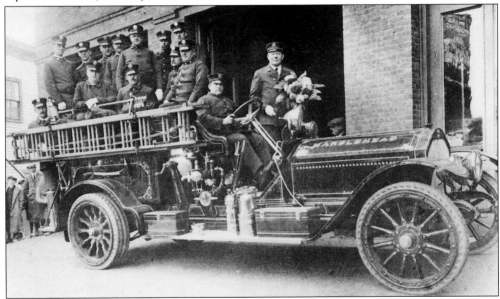

Departure for a Firemen's Sunday parade (photographed 1914). Spectators on the sidelines of the Central Fire House on School Street watch as twelve firemen squeeze into the town's second piece of motorized fire-fighting apparatus. Made by the American LaFrance Company of Elmira, New York, the 6-cylinder engine could discharge 750 gallons of water per minute. Chief John T. "Boney" Adams, who served from 1908 to 1921, is shown holding a large floral bouquet, probably secured in a nineteenth-century fireman's speaking trumpet. (Courtesy Wilkinson collection.)

101

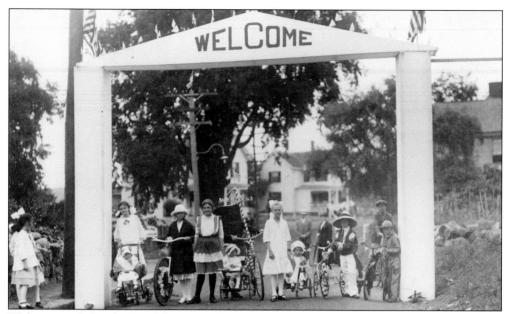

Welcome arch for the Pond Street Associates' celebration (photographed 1915). Costumed youngsters with decorated vehicles pose during an annual Fourth of July observance. Two band concerts, a parade, athletic events for boys and girls, and a daylight fireworks exhibition, along with the traditional reading of the Declaration of Independence by John N. Osborne, were enjoyed by all. (Courtesy Knight collection.)

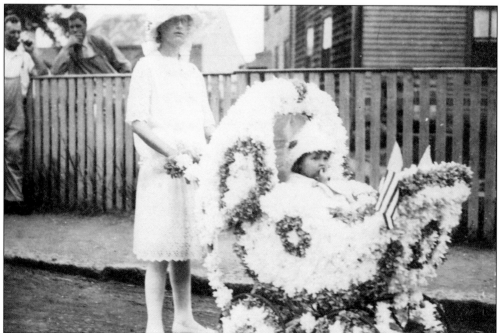

Off to the Pond Street Associates' Fourth of July parade (photographed 1913). Ida Dutton Snow and her ward for the day, Edgar Ingalls Bartlett Jr., are about to join the grand parade. Admiring the patriotically decked-out carriage are Knott V. Martin and his neighbor, Ralph Buswell. (Courtesy Cutler collection.)

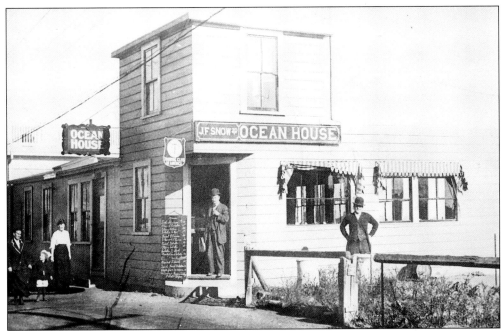

Ocean House, Front Street (photographed c. 1915). Hoping to attract motorists as well as passengers on the Boston & Northern Street Railway trolley line, Joseph F. Snow 2d. displayed the official shield-shaped sign of the Touring Club of America above the main entrance to his box-like restaurant. The blackboard menu listed a fish dinner for $1 (the most expensive item) and apple pie and ice cream for 10¢. One of the women on the sidewalk was Lilly "Bug Juice" Snow, and one of the gentlemen was nicknamed "Squeak" Snow. (Courtesy Cuzner collection.)

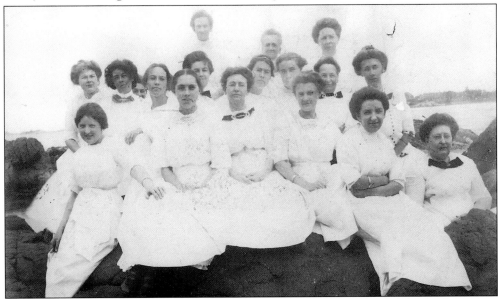

Waitresses "on the rocks" (photographed c. 1915). Eighteen waitresses dressed in white (many wearing the popular black neck ribbons of the period) gathered for this group photograph at Fort Beach near their place of employment, the Adams House restaurant. (Courtesy Cutler collection.)

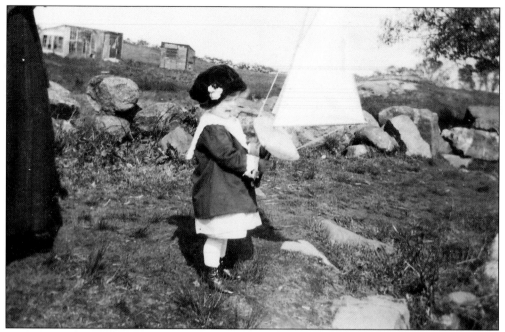

"But its not a doll!" (photographed c. 1915). Well in advance of his time, William O. Doherty presented this model sailboat to his eldest daughter, Evelyn, probably on or near her birthday. (Courtesy Cuzner collection.)

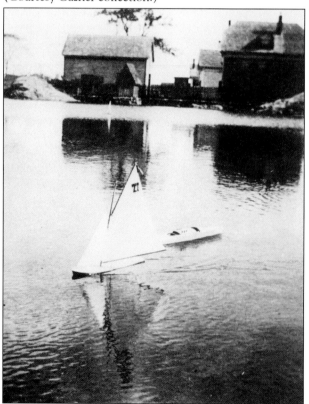

Redd's Pond, end of Pond Street (photographed c. 1915). Marblehead's only connection with the witchcraft hysteria that swept Salem and other parts of Essex County in 1692 is the site of Wilmot Redd's small house on the southeast side of the pond bearing her name. "Mammy" Redd was hanged on Gallows Hill in Salem on September 22 of that delusional year. The pond once served as the town's freshwater supply, and in 1877 after the great fire of that year $10,000 was appropriated to enlarge the water source and build a reservoir. (Courtesy Cuzner collection.)

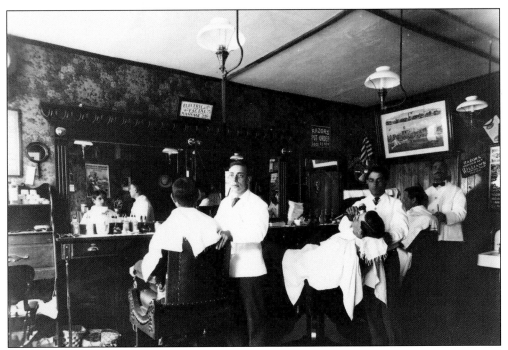

Lewis Allen's barber shop, 109 Washington Street (photographed c. 1918). The barber in the foreground is Mike Musto, who was born in Italy and arrived in Marblehead around 1900. After working a few years for "Lew" Allen, Musto, who was also an electrician, opened his own barber shop. The customer seated in the middle golden-oak and leather-upholstered chair is treating himself to an electric facial in the neat, floral-wallpapered shop with its Larkin desk and gas chandeliers. (Courtesy Cutler collection.)

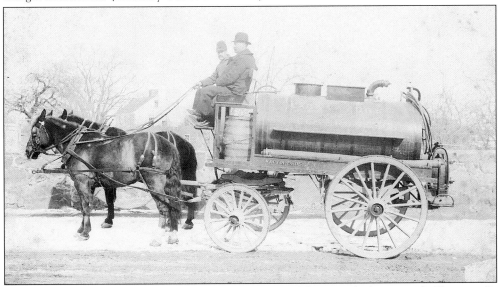

Benjamin Franklin Martin Jr. and his "honey cart" (photographed c. 1919). Flies usually swarmed around the Martin Brothers' horse-drawn wagon when they made the rounds to clean cesspools and cisterns. Charlie Foss is driving the honey cart either to the next job or back to 22 Pond Street. (Courtesy Chadwick collection.)

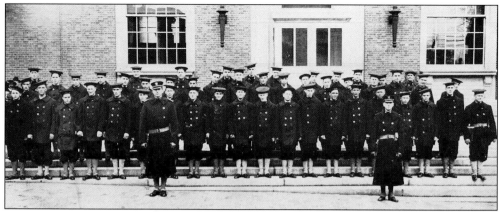

National Naval Volunteers in front of the post office, Pleasant Street (photographed 1917).
The steps of the former post office accommodated the rows of young volunteers assigned to duty on the USS *Nebraska* on April 1, 1917. June 5 was the first registration day for draftees between the ages of twenty-one and thirty-one, and Marblehead registered 543 men. Second Lieutenant Charles Herbert Evans (born 1887) was the first local young man to die in World War I, during the battle of Chateau Thierry in France on July 20, 1918. (Courtesy Cuzner collection.)

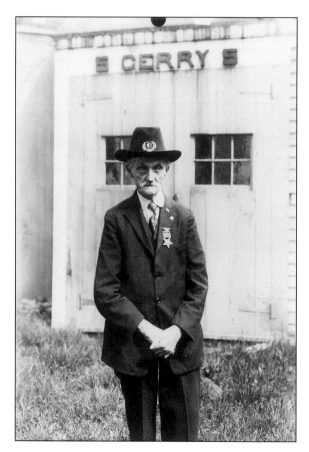

Civil War veteran (photographed c. 1915). In 1914 Marbleheader William E. Low compiled a diary of his experiences in Company I of the Twenty-third Regiment during the Civil War. Low, a twenty-year-old mechanic from Essex, Massachusetts, was mustered in on October 9, 1861; wounded on June 3, 1864, at Cold Harbor, Virginia; and mustered out on September 27 of that year. The elderly veteran is shown standing in front of the Gerry Engine No. 5 hand-engine's headquarters on State Street near Washington. (Courtesy Marblehead Historical Society.)

Marblehead OKO Band on the Town House steps (photographed c. 1917). Bandleader Harris stands behind the marching drum with members of this local band, named for the Okommakamesit hand-engine, which raised money for the war effort. The hand-held sign at the right refers to the megalomania taking place in Germany at the time. (Courtesy McGrath collection.)

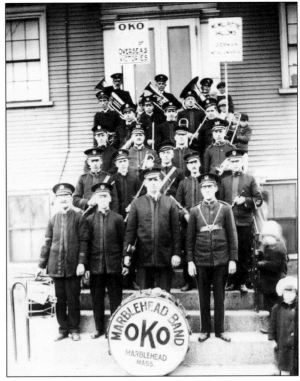

Corporal Abraham Sacks (photographed 1918). Born in 1898 in Roxbury, Massachusetts, Abraham Sacks worked as a tailor and rented a small apartment from a Marblehead family before enlisting in the war. When he returned he started a small antique business, according to his son, Stanley S. Sacks, a longtime proprietor of the antiques shop now at 38 State Street. (Courtesy North Shore Jewish Historical Society.)

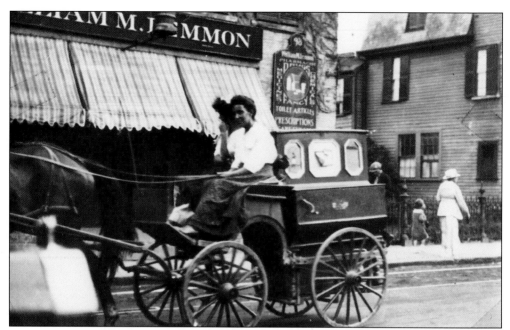

Hurdy-gurdy on Washington Street (photographed c. 1918). Hand-pulled music boxes and vehicular hurdy-gurdies, such as this one driven by a young woman, played popular tunes of the day when operated by a hand crank. The wagon is passing the apothecary shop of "Billy" Lemmon, which sold not only "fancy toilet articles" but the best Cuban cigars in town. The shop was known as a nightspot where gentlemen talked politics and smoked those cigars. (Courtesy Cutler collection.)

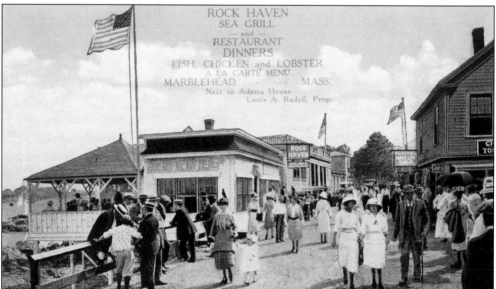

Rock Haven Sea Grill and Restaurant, Front Street (c. 1920 postcard). Fancy-dressed people promenade along the busy street, perhaps on a Sunday, while others enjoy shore dinners in the open-air dining room pavilion set on pilings over the rocky harbor. Tourist items, cigars, and tobacco were sold in the store at the right, the Rock Haven Novelty Shop, owned at the same time by restaurateur Louis A. Radell. (Courtesy Swift collection.)

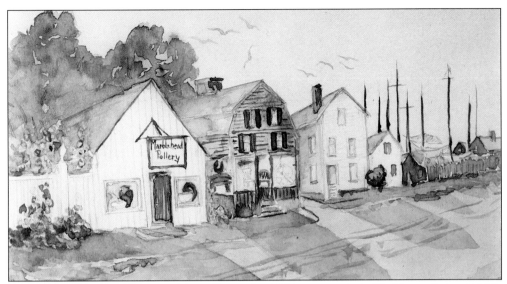

Marblehead Pottery shop, 111 Front Street (c. 1920 watercolor). Ida Upton Paine (1860–1936), a Salem china painter, made this watercolor of the work and retail shop. The small building, located to the right of The Leslie hotel, was acquired in 1915 by Arthur Baggs from founder Dr. Herbert Hall, who prescribed various handicraft activities as a way to treat emotionally disturbed patients. Around 200,000 pieces of art pottery were produced between 1908 and 1936, when Marblehead Pottery closed shop mainly because of the Great Depression. (Courtesy Peabody Essex Museum, Salem, Massachusetts; formerly in the author's collection.)

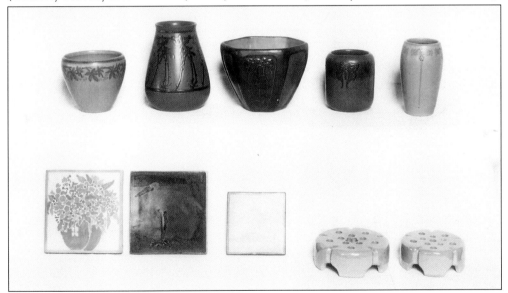

Examples of Marblehead Pottery (photographed c. 1925). In 1919 the company's first mail-order catalogs were printed; the fifty illustrated pottery shapes included these forms and slight variations. Pottery colors included green, gray, orange, rose, tobacco brown, wisteria, and, the most popular, Marblehead blue. The pieces were trademarked initially with a small, circular printed label of a head-on masted vessel below the name "MARBLEHEAD." After 1908, the same motif was incised on the unpainted orange-brown clay bases of objects, without the name but flanked by an "M" and a "P." (Courtesy Marblehead Historical Society.)

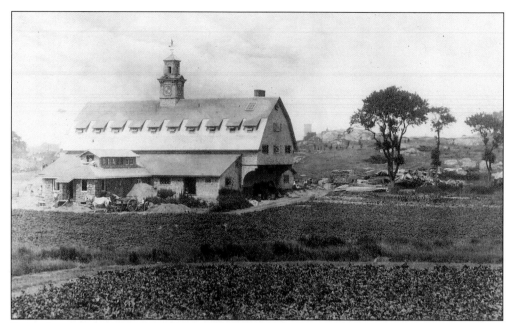

Dairy barn, Sorosis Farms, Clifton (photographed *c.* 1922). A copper weather vane of a Native American surmounted the cupola of the largest barn on the farm off Marblehead Road. Established by the A.E. Little Company and the A.E. Little Shoe, the farming venture allowed the company's employees to purchase all farm-related products at cost for their families. Sorosis Farms soon became a leader in the breeding of the finest blooded cattle, sheep, swine, and poultry in New England. Bankruptcy following the Great Depression forced the closing of this experimental farming enterprise. (Courtesy Abbot Public Library.)

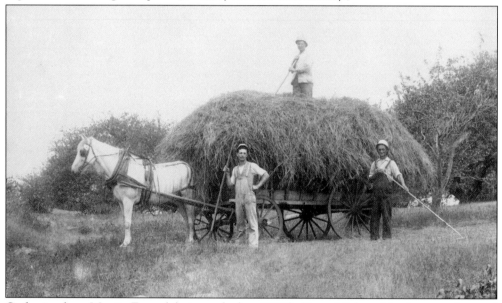

Gathering hay, Martin Farm (photographed *c.* 1920). Knott Vickery Martin, one of several with the name in succeeding generations, is on top of the full hay wagon, while brother Henry stands near the horse. A helper, thought to be named Mace, has also put in a good day's work. (Courtesy Cutler collection.)

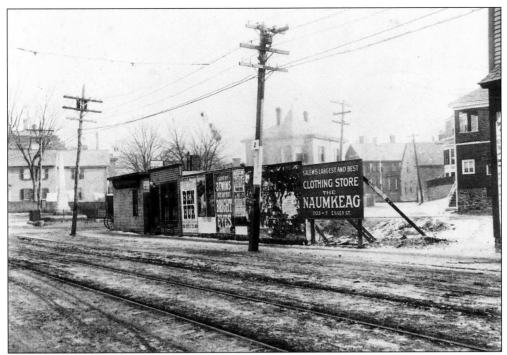

Billboards and trolley tracks near the intersection of Essex and Bassett Streets (photographed 1917). The fenced-in obelisk at the left is the Mugford Monument (see page 46), which was erected on the site in 1876. The most visible and interesting poster is that which advertises the 1907 silent film *Ben-Hur* at a Boston theater. The poster for The Naumkeag, a department store at 203–7 Essex Street in Salem, is a coincidence in that the street behind the row of billboards is Essex Street. (Courtesy Slee collection.)

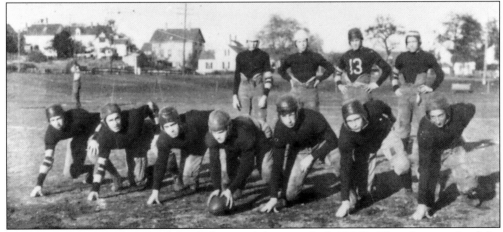

The Marblehead High School football team (photographed 1920). This photograph of the hometown team was taken at Seaside Park on Atlantic Avenue. Due to coach Ray Pendleton's expertise the gridiron guys won five games, tied an equal number, and lost only two that season. The players are, from left to right, as follows: (kneeling) Bill Alton Hunson, Warren Mason, Hughie Doherty, Harry "Heaphy" Martin, Jack Clay, Gordy Doliber, and Coney Peach; (standing) Howard Eustis, Sumner Sweetland, captain John "Tinker" Gilbert (No. 13), and Joe Tansey. (Courtesy Wilkinson collection.)

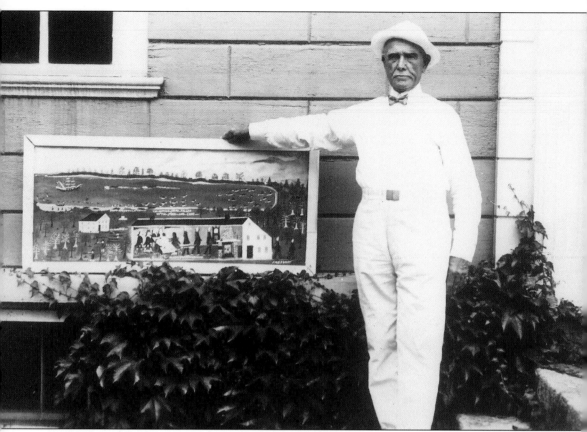

J.O.J. Frost with one of his paintings (photographed c. 1923). Native-born naïve local history artist John Orne Johnson Frost (1852–1928) is a solemn but smart-looking septuagenarian in his white outfit and bow tie as he stands next to the garden side of the Lee Mansion with the painting he inscribed "When Marblehead bought/The town from the Indians/1684—For 16 lbs 84 Dol./Showing the old Codner House/Built 1640 on Front St." Though hardly salable during Frost's lifetime, his "primitive" paintings have become eagerly sought by American folk art connoisseurs. He was born on the street depicted in the painting, at 47 Front Street (near the entrance to Crocker Park), and for several years he and his wife, Annie Lillibridge Frost, lived diagonally across the street at no. 54. At one time they owned a restaurant in town, but J.O.J. Frost is best remembered for selling sweet-pea flowers and small, oil-based land- and seascapes from his wheelbarrow. (Courtesy Marblehead Historical Society.)

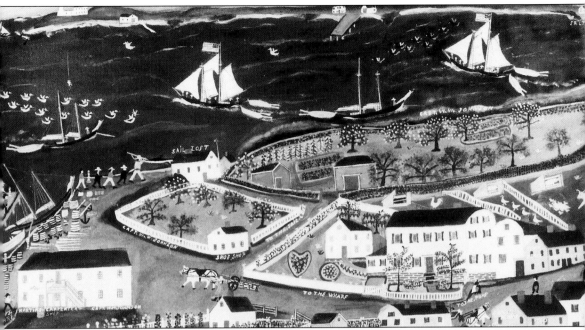

Waterfront of the Old Town, **house paint on Masonite by J.O.J. Frost (1852–1928),**
 c. 1924. This medium-size painting in a horizontal format (approximately 24-by-47 inches)
resembles a Victorian crazy quilt in the way the different geometric and soft shapes and colors
are juxtaposed. The charm of Frost's narrative paintings is in their historic documentation of
past town-related events which he carefully recorded, as well as in their being a map of the
scene represented. It is not easy to get lost in a Frost painting, and there is much to savor in his
nonacademic, naïve handling of the pigment. While a widower at 11 Pond Street, the artist
had a handbill printed to announce the opening on August 13, 1924, of "his new art building
containing about eighty paintings of the Grand Bank [sic] and in the town of Marblehead."
(Courtesy Marblehead Historical Society.)

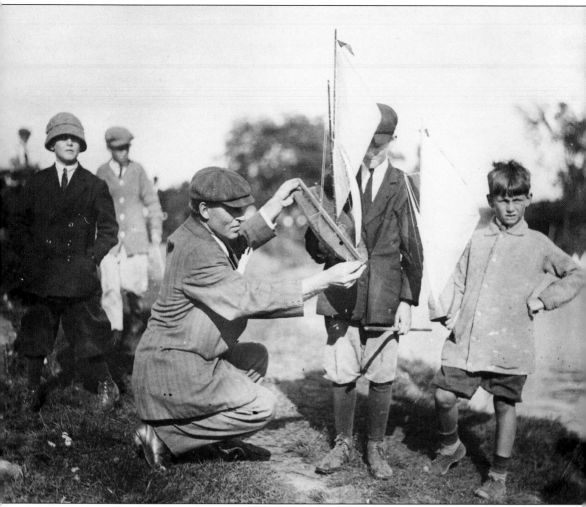

Last-minute inspection, Redd's Pond (photographed c. 1925). William O. Doherty checks out a young friend's model yacht before a Sunday morning race, while Leonard Fowle (right) gazes at the photographer. Fowle's boyhood interest in sailing was useful when he became a writer for a national yachting magazine and when he wrote for the *Boston Herald*. Margaret B. Hennessey, the widow of Arthur I. Hennessey, continued the classes in making model yachts and the ABCs of sailing them, which her husband started in 1919. A later brochure stated that "In the classes the children are taught the making of the model yacht from the shaping of the block of wood to the rigging of the spars and sails. . . . At the close of each season, a Regatta and races are held by the model yachts and their young skippers." (Courtesy Cuzner collection.)

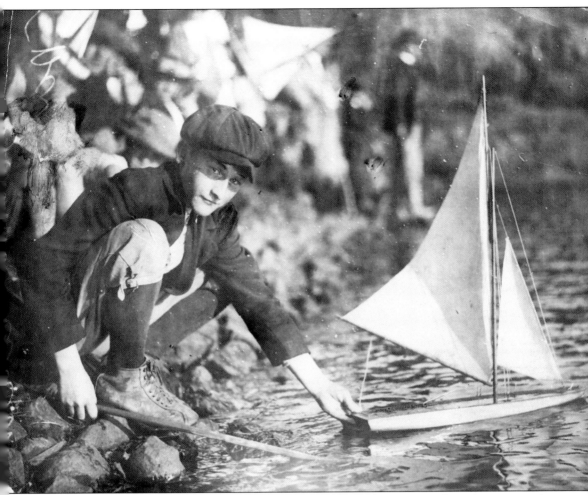

Young sailor at Redd's Pond (photographed c. 1925). Before he grew up to become a respected naval commander, Frederic W. Kinsley sailed and lost a 24-inch Marconi model yacht to the depth of the pond. "The deck curled up, and because the lead keel was so heavy, it sank!" recalled the experienced sailor some seventy-one years later. Previously, long poles were used to steer the model yachts, but today much older boys use sophisticated radio-controlled devices to electronically "wend their way from end to end at Redd's Pond." (Courtesy Cuzner collection.)

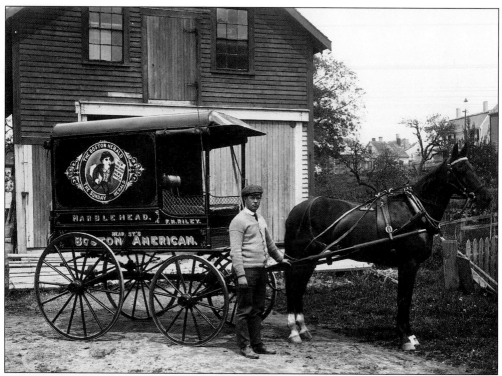

Boston newspaper delivery service (photographed c. 1925). A handsome horse and distinctive hand-painted wagon owned by F.H. Riley were used by Jack Riley to deliver the two popular newspapers to Marblehead retail shops. The young man was photographed in front of Phil Woodfin's barn on State Street. The first local newspaper, the *Marblehead Register*, was issued in March 1830. (Courtesy Chadwick collection.)

Eddie Holden as a femme fatale (photographed c. 1925). The third owner of the Squash House, Edward N. Holden, evidently enjoyed playing the part of an actress as well as an actor. He was an accomplished pianist and church organist, and his home at 76 Pleasant Street was filled with antiques and Marblehead memorabilia. (Courtesy Wilkinson collection.)

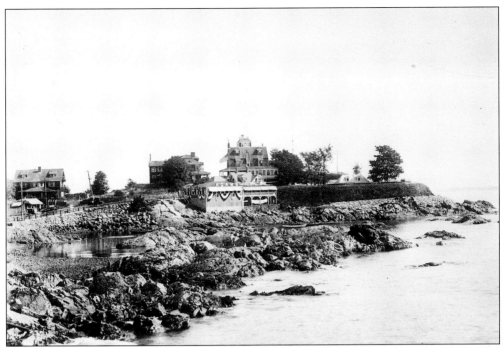

Adams House Annex, near the entrance to Fort Sewall (photographed c. 1926). The caretaker's house for the fort was acquired and then converted into a restaurant by John T. Adams for the overflow of diners. One hundred and twenty or so diners could be accommodated in the facility, here decked out in red, white, and blue bunting, undoubtedly for the Fourth of July. The three large houses silhouetted against the sky are still at their original locations. (Courtesy Cuzner collection.)

Clams from the Adams House,
Marblehead, Mass.

(Private collection.)

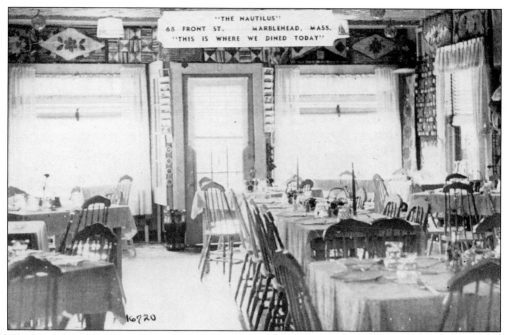

The Nautilus, 68 Front Street (c. 1935 postcard). Located across from Tucker's Wharf, this small dining room was nicely appointed but with no apparent nautical theme. (Courtesy Swift collection.)

Castle Brattahlid, 2 Crocker Park Lane, built 1926 (photographed c. 1930). This ivy-covered, picturesque stone fortress was modeled after the ancient castle of Eric the Red in Greenland. Constructed from the blasted-out surrounding rocky ledge according to the plans of the owners, Mr. and Mrs. Waldo Ballard, the castle features tapered stone walls, a dungeon, and a secret stairway. Two hundred guests could be seated at one time for dinner in the commodious hall. L. Francis Herreshoff, a yacht designer, acquired the castle in 1945. (Courtesy Chadwick collection.)

118

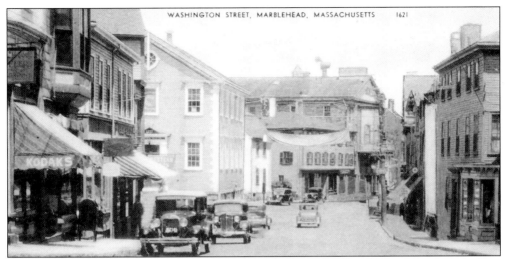

Washington Street looking past the Town House (c. 1930 postcard). The imposing 1844 Greek Revival Lyceum Theatre (in the middle background) was the site of numerous public lectures and related cultural events, including the showing of the locally filmed silent motion picture *The Pride of the Clan* (1916), starring "America's Sweetheart," Mary Pickford. Ticket holders also enjoyed burlesque and minstrel shows in the five-hundred-seat theater before it was razed in 1951. (Courtesy Swift collection.)

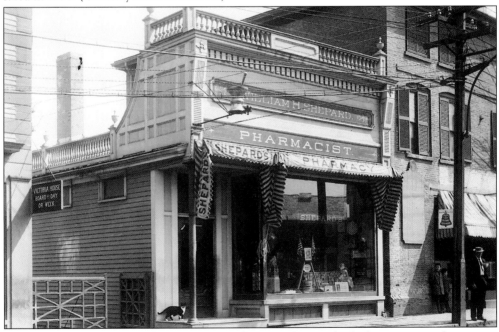

William H. Shepard's pharmacy, 96 Washington Street, built late nineteenth century (photographed c. 1930). A fancy High Victorian false-front pediment added architectural distinction to the one-story pharmacy built by "Doc" Shepard when he was forced to vacate his former shop in the brick building next door. A gilded mortar-and-pestle trade sign over the entrance caught the attention of individuals who might be in need of the pharmacist's special Anodyne Expectorant for a winter cough, which sold for 30¢ a bottle in 1918, the year of the great influenza epidemic. (Courtesy Chadwick collection.)

119

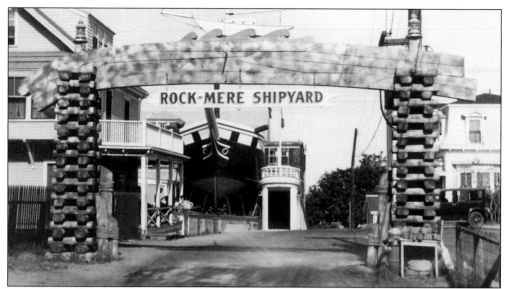

"Rock-Mere Shipyard" (c. 1930 postcard). A log-stacked archway surmounted with fore-and-aft lights and a centrally placed sailing vessel riding on wooden waves greeted guests to The Rockmere hotel. Located at Pier No. 1, Allerton Place, the yard also had a large-scale replica of the eighteenth-century vessel *Hannah*, with an old pilot house from a tugboat serving as the main entrance. Gangway lights from the submarine S-4 illuminated the way in the evening. (Courtesy Swift collection.)

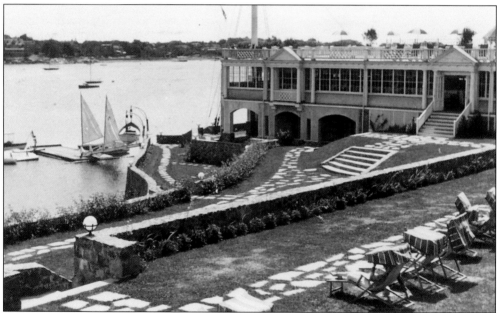

Fo'cas'le at The Rockmere (c. 1930 postcard). Terraced lawns and lawn chairs invited guests at the famous hotel to relax and enjoy the surrounding scenery. The classically inspired "dine and dance" restaurant opened in 1929, several months before the Great Depression. The veranda on the quarter deck, named the S.S. Rockmere, featured tables, seats, and colorful umbrellas. During the season a gun would be fired at sundown as all vessels in the harbor had their flags lowered while crew members stood at attention. (Courtesy Swift collection.)

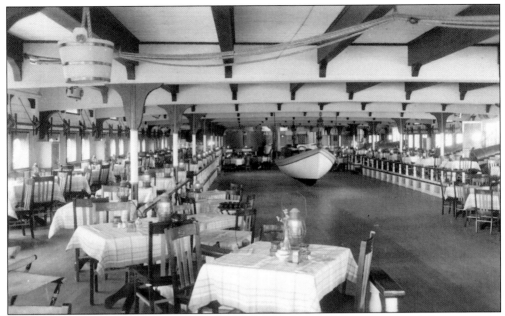

"The Gun Deck in the Fo'cas'le" (c. 1930 postcard). The most unusual feature of the nautically inspired Gun Deck was the quarter boat suspended over the long dance floor, with Morey Peal's musicians playing inside. Several cannon, supposedly from *Old Ironsides*, and an old capstan from the USS *Chesapeake* imparted maritime presence to this dining and dancing experience. (Courtesy Swift collection.)

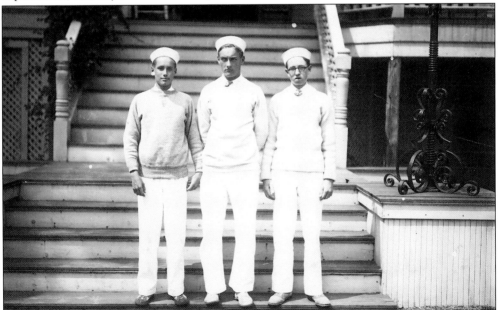

Bellhops at The Rockmere (photographed c. 1930). Sailor caps and whites were worn by young men employed as bellhops at the town's largest waterside hotel. The elaborate wrought-iron lantern base (one of two) stood on a deck near the entrance. These may have been the same bellhops who were stationed there when President and Mrs. Calvin Coolidge and their entourage visited the hotel in the summer of 1926. (Courtesy Cutler collection.)

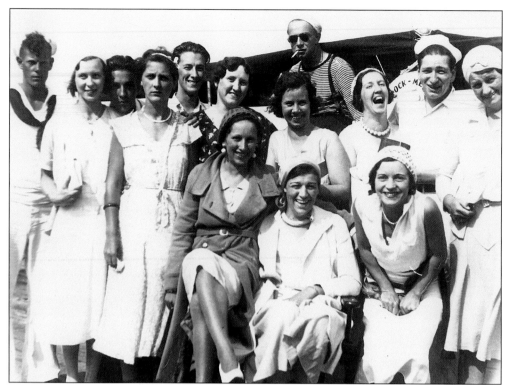

Telephone girls on a float at The Rockmere (photographed 1931). A group of telephone company employees share a joyous moment (all except one) with crew members of Raymond O. Brackett's yacht on a sunny summer afternoon. From left to right, they are as follows: Mary MacEachern, Louise Martin, Emily Thorner, Elizabeth Knight, Elizabeth Pedrick, Elizabeth Glover, Frances Marcott, Nellie E. Holden, and Sally Glover. (Courtesy Cutler collection.)

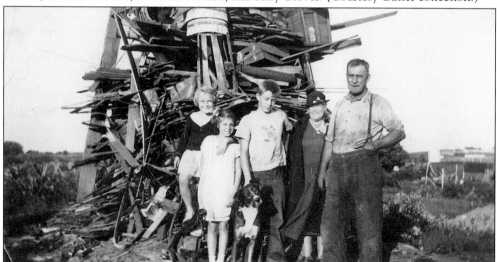

Before the bonfire (photographed c. 1935). Alvah Beaumont Neily looks as if he did most of the work stacking wooden debris for the annual Fourth of July bonfire. Standing with him in the pastures off Peach Highlands are Aunt Fanny, his son Paul (wearing an early Mickey Mouse shirt), Janet V., Judy, and interested onlooker, "Bruno." (Courtesy Ellen Neily Antiques.)

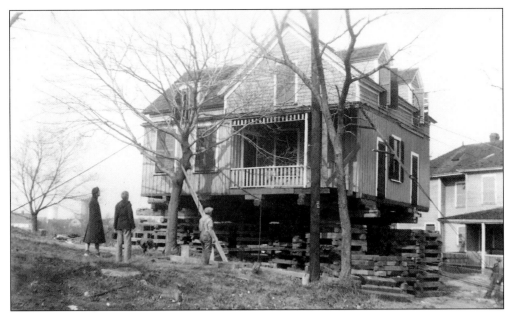

Moving a house on Harbor View (photographed c. 1934). No. 5 Harbor View, the summer home of Mr. and Mrs. Robert Seamans of Salem, was relocated to the other side of the L-shaped dirt road which extends to the harbor near the causeway. To avoid possible injury, the house was moved off-season when neighborhood children were back in school. (Courtesy Edith Abbot.)

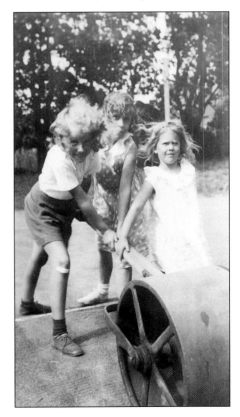

Smoothing the clay surface of the tennis court, 7 Harbor View (photographed c. 1935). On a sunny but windy day Hope Williams, despite her bandaged knee, helps Caroline Abbot and younger sister Madeline roll a large drum several times over the tennis court behind the summer home of their parents, Mr. and Mrs. W. Lyle Abbot. (Courtesy Abbot collection.)

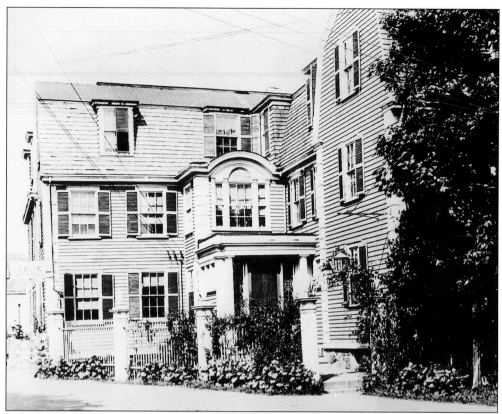

The Leslie, 113 Front Street (photographed c. 1935). The town's premier early-twentieth-century inn was named for the British officer Colonel Alexander Leslie, who figured locally and in Salem in non-combative occurrences during the early days of America's fight for independence. Percy Alexander, who owned the inn at one time, may have been responsible for its quaint and inviting appearance, which featured a Palladian window, urn-topped picket fence, and flower-filled welcoming entrance. (Courtesy Cuzner collection.)

(Swift collection)

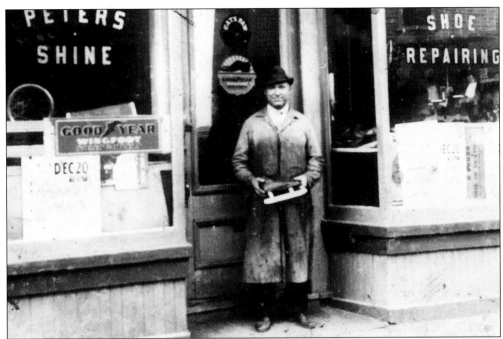

Peter's shoe repair shop, 79 Washington Street (photographed c. 1935). Carrying on the craft of the Yankee cordwainer and shoe repairer, Sicilian immigrant Peter Mormino seems justifiably pleased with the ice skate he has just sharpened for a customer. An earlier owner of the building, Henry Rea, had a ballroom on the third floor of his tavern. (Courtesy Wilkinson collection.)

Wallace Dana Weed, the "Poet Postman", **oil on canvas by Orlando Rouland (1871–1945), c. 1934.** The convivial postman (1872–1958), a veteran of the Spanish-American War, was painted in the Impressionist style by New York artist-teacher Rouland, who summered in a house at 5 Lookout Court. (Courtesy Abbot Public Library; photograph by Bill Lane.)

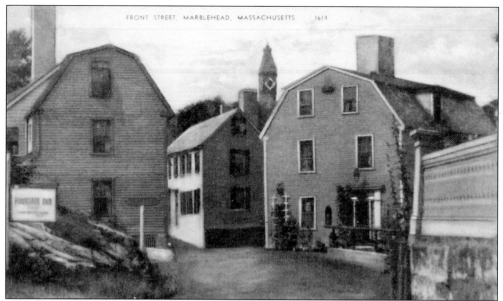

Sea Horse Dining Room, corner of Front and Darling Streets (c. 1935 postcard). This interesting composition of roof shapes, fences, and topography could be only one place, as indicated by the tower of Abbot Hall. The signage used on or in front of the building attracted the attention of passersby and summer celebrities to whom the establishment catered. Artist Silas B. Duffield, E. Laura Vose, and Marshall Foote ran the restaurant in the former mid-eighteenth-century Homan-Bowler House. (Courtesy Maurais collection.)

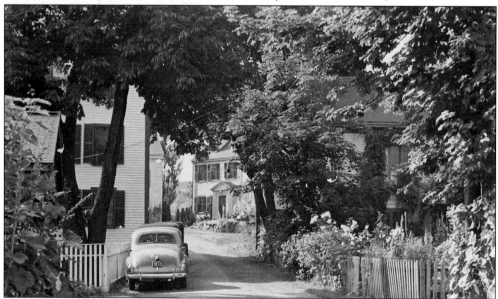

Glover Square (photographed 1938). Hollyhocks—long associated with Marblehead—and late summer vegetation frame an eighteenth-century house situated on a slope at the bend of this L-shaped street. In a 1930 Boston newspaper article, a chatty contributor wrote that "in Marblehead the ocean, the quaint old houses, the narrow curving streets that stroll a little way and then forget their destination, all serve as background for the glorious abundance of hollyhocks." (Courtesy Bull collection.)

126

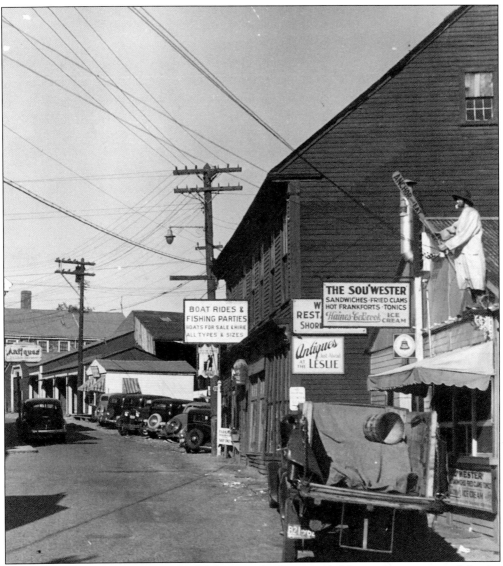

Front Street near the Town Wharf (photographed c. 1939). Various businesses vied for the patronage of motorists and pedestrians along this curved section of Front Street near the busy and scenic wharf. Dining, harbor sightseeing and fishing, and antiquing took precedence over any small business that happened to be located in the area. The full-size figure of a fisherman wearing an oilskin slicker and holding an oar stating "ANCHOR and EAT" greeted customers to Jim Walsh and Betty Preston's restaurant, The Sou'wester. The large, wood-framed building to the left and the others beyond the parked cars belonged to Stearns & McKay until 1930 when Graves Yacht Yards acquired the active boatyard. Congested utility poles and crisscrossed wires will also become part of the past, as the townspeople of Marblehead wisely voted in 1996 to have utility lines buried underground in the picturesque historic district. (Courtesy Wilkinson collection.)

Acknowledgments

Many special Marbleheaders, and other special people who are as enamored of the town as I am, deserve to be credited for helping a "stranger" compile this pictorial history. A trio of octogenarians who graciously and generously supplied a wealth of written, oral, and photographic material are Benjamin Chadwick, who when I first met him said, "Call me Uncle Ben; everyone else does!"; Louise Graves Martin Cutler, a spunky lady known to her friends as "Cornball" (a Martin family nickname); and Harry Wilkinson, referred to as "Mr. Whip" by the *Marblehead Reporter*, which has published his "Down Memory Lane" articles for thirty years.

Helpful institutions and the individuals who work for them are as follows: Abbot Public Library (Bonnie Strong, director; Victor Dyer and Jonathan Randolph, reference librarians); Boston Public Library (Sinclair Hitchings, keeper of prints; Karen Smith Shafts, assistant keeper of prints); Lynn Historical Society (Kenneth C. Turino, director; Fay Greenleaf, administrative assistant; Stephen J. Schier, registrar); Marblehead Arts Association (Nancy Ferguson, director); Marblehead Board of Selectmen (Thomas A. McNulty, chairman; William E. Conly; F. Reed Cutting Jr.; Diane E. St. Laurent; William M. Purdin; Patricia D. Charbonnier, administrative aide); Marblehead Historical Commission (Joyce Booth; Marion Gosling; Elizabeth McKinnon); Marblehead Historical Society (Edmund P. Bullis, president; Judy Anderson, administrative director; Mikey Cutting and Karen MacInnis, catalogers); Museum of Fine Arts, Boston (Karen L. Otis, photographic services department); North Shore Jewish Historical Society; Peabody Essex Museum (Dean T. Lahikainen, curator of American decorative arts; Paula B. Richter, assistant curator; Geraldine Ayers, maritime department; Kathy Flynn, photographic department); Skinner, Inc. (Stephen Fletcher, vice president; Anne Trodella, public relations associate); Wadsworth Athenaeum (Amber Woods, assistant to the registrar); Miss Edith B. Abbot; Mr. and Mrs. David F. Barry; Mr. and Mrs. Garrett D. Bowne; Mr. and Mrs. Norris L. Bull Jr.; Mrs. Benjamin R. Chadwick; Dr. Raymond F. Cole Jr.; Peter Combs; Mr. and Mrs. William R. Creamer; Abbott Lowell Cummings; Mr. and Mrs. Frederick W.E. Cuzner; Carol Howie Eldridge; Robert Selman Graves; Mr. and Mrs. James R. Hammond; Nicholas Hammond; Robert L. Howie Sr.; Robert L. Howie Jr.; Retired Commander and Mrs. Frederic W. Kinsley; Mrs. Russell W. Knight; Mr. and Mrs. David L. Ladd; Robert Landry; Bill Lane; Scott F. Lanes; Peter B. Little; Charles F. Maurais; Vincent F. McGrath; Peter and Ellen Neily; Carolyn H. Nichols; Harriett C. Nichols; Mr. and Mrs. Alexander Parker; Bernice Randall; Dr. and Mrs. Eugene E. Record; Nancy Rexford; Mr. and Mrs. Thomas H. Rhoades Jr.; Stanley S. Sacks; Barbara Sanders; Mr. and Mrs. Richard Slee; Robert Swift; Christine C. Vining; Joan von Sternberg and family; Allan Peyton Hawkes Waller and Christine Whalen Waller; Nathalie Woods; Daniel Pingree Windsor Wright; and Peter Zaharis.

Very special thanks to Gail Pike Hercher for reading the initial manuscript; to Judy Anderson for editing the same with her historical perspective; and to Carol Swift for her ongoing joyful enthusiasm.